IMAGINE.
SHOOT.
CREATE.

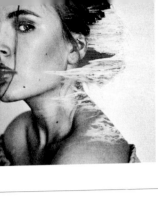
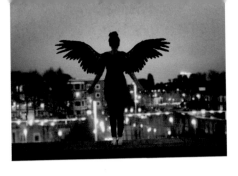
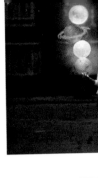
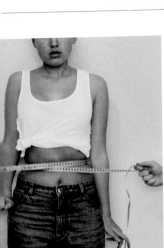

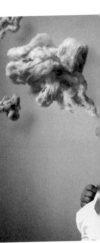
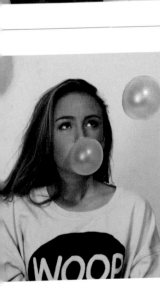

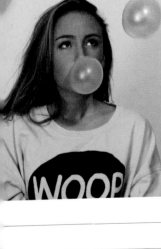

IMAGINE.
SHOOT.
CREATE.

ANNEGIEN SCHILLING

ilex

CONTENTS

FOREWORD

Annegien cycles through the center of Utrecht. She parks her bike by the door to a parking garage, and as soon as people come out, she slips through the doorway and runs up to the empty roof. There she removes a tripod from her backpack, positions it, and screws a camera on top. She checks where the light is coming from, feels whether there's any wind, looks through the lens, and frames the picture. She presses the self-timer, runs a hundred feet away from the camera, and jumps in the air with one hand raised, then runs back to the camera to examine the result. At the fifteenth attempt, she's finally satisfied. She then takes a red balloon from her bag and blows it up. She takes the camera off the tripod, releases the balloon, and photographs it as it rapidly disappears from view.

That's how I got to know Annegien. She was 15 at the time. I was spending a day with her researching for a documentary about successful children online. Annegien had immediately sparked my curiosity with her Instagram account. Not just because of her enormous number of followers, but because she far surpassed her fellow Instagrammers and peers in terms of originality and creativity.

Annegien is not a girl who has produced a few nice photos by accident. Her images testify to a great imagination. She makes the viewer curious about the meaning. The images are very diverse in terms of style, shape, color, and content. The mood ranges from delicate, tough, or gloomy through to sinister and comic. The images and the texts that Annegien places alongside them say something about her view of the world, and about Annegien herself.

At the age of 15 she had already achieved the thing that many (young) YouTubers dream of: more than half a million followers. But whilst most YouTubers are looking for fame, attention and wealth, Annegien has no interest in those. That intrigued me even more. Who is this Annegien, the girl with (at that time) 664k followers?

A year later we shot footage for the documentary *Het meisje van 672k* (*The Girl With 672k*). Annegien introduced me to a world that I knew nothing about. She has shown how you can use social media in a remarkable way. Using Instagram, she created her own audience for her "edits." She has maintained that, and handles it carefully. Annegien has developed into an artist whose personal online gallery touches and inspires nearly 900,000 viewers at the time of writing. A dream for any artist.

Mirjam Marks

FETCHING TIGERSS

When I was thirteen, I started an Instagram account with the username fetching_tigerss. Tigers were my favorite animals, and in this context, fetching means something like "awesome" or "cool." The extra "s" stands for Schilling. At the time of writing, Fetching tigerss has more than 895,000 followers around the world.

When I was younger, I often painted with my father on Sundays. I enjoyed being creative—along with soccer, it was a release valve for me, and it made me very happy. I grew up in a creative environment and was always interested in photography. I used to write in friends' albums that I wanted to be a photographer. Or a soccer player. Even though I had never even touched a camera!

For my eighth birthday, I got my first camera: a pink Samsung that I took everywhere. I edited my photos in Windows on my parents' computer. I played with the contrast and made Movie Maker videos with them. When I was 13, I got an iPod and started on Instagram. If I make something, I want to share it. I find it difficult to keep it to myself.

I ALWAYS USED TO WRITE IN FRIENDS' ALBUMS THAT I WANT TO BE A PHOTOGRAPHER. OR A SOCCER PLAYER.

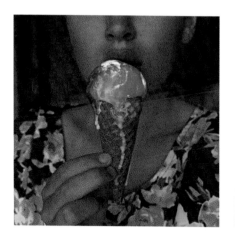

I take photos that are entirely related to me, but I also take photos in which I record something that does not necessarily apply to me personally, but that I think is important. They're messages that can apply to anyone. This photo is about a universal issue: the environment.

———

MY IMAGES ALLOW ME TO PASS ON MESSAGES ABOUT THINGS THAT I FIND IMPORTANT

I'm the last person you'd expect to have an Instagram account with so many followers. I'm very shy. My friends didn't want to be in my photos in the beginning, so I photographed myself. It's not necessary for my photos to include me—it could have been someone else, or an animal. What I'm interested in are the concepts, the ideas that I want to show.

Within two months, I had more than 100,000 followers. I realized that I could do more with it, that I had a voice and could tell my own stories and messages. With my work, I can also reach young people. Young people don't have a lot of art to relate to—most works of art are made by adults. My images allow me to pass on messages about things that I find important, in a playful way.

Followers' comments make you more alert. I scan around 90 percent of them. In the beginning I mainly created images for myself, because I really enjoy doing it. Now fetching_tigerss is a personality, shaped by the influence of my followers, and I make things for other people, which is also great. That's grown organically, and it still feels as if I have just 200 followers. My followers are people that I can't see, but who I do feel are saying to me "go and create that photograph." I feel more pressure to produce a photo than to do my homework!

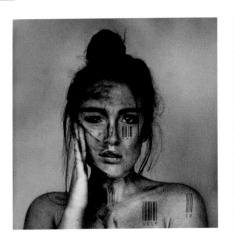

With this photo I want to show that everyone gets labeled. People are quick to judge. You can wipe out those labels, but they remain visible. And removing them takes effort—it hurts.

I like to stick to my own inspiration, and don't look at other people's photos much. But there are other Instagrammers I follow, like Isabella Madrid and Natalia Seth of Escaping Youth. We think roughly the same, combining concepts. They are much stronger than I am when it comes to beauty and details; I have a different style in that regard.

You can analyze our images in the same way. They have the same structure. The starting point for us, for the makers, is always a realistic image to which you then add something magical. It's really the opposite of what I'm doing in this book—dissecting the magical final photo into realistic images and steps.

It's all about looking around you in a particular way. Everyone who does this has taught themselves to do it.

That's why I never show my unedited photos within the community in advance. The in-crowd would be able to spot immediately what I'm going to do: these people look at the world in the same way I do. I can tell by other people's "before" photos what they are going to create.

I'm very critical of my own work: there's no such thing as a perfect photo. So the pressure of time means I often have to find a compromise: This photo is good enough for today, even though I know it could be better. In a few days' time, I can show something new again. Photography is particularly about doing, doing, doing. And looking. Everything begins with looking, with seeing more than the camera sees.

This is the first photo I edited. I originally created it with my iPod, but I've made it afresh for this book. For me, this photo is about seeing more than the camera sees.

EVERYTHING BEGINS WITH LOOKING, WITH SEEING MORE THAN THE CAMERA SEES.

IMAGINE

IMAGINE

In order to be able to create—whether it's painting, photography, or something else—you must be able to look, and always pay attention to details. This helps me massively in coming up with a concept. You can train yourself to look: I can spend hours looking at the same flower. It's not just objects that inspire me, but also stuff like color combinations, or the way a leaf falls from a tree, the curve it makes on its way down.

I look at it this way: In my head, I have an archive of objects, colors, and shapes. These are universal, recognizable things, like a fish or a dollar bill. Seeing something on the street or a particular event allows me to link together two objects or situations from that archive. Separately, they usually have little to do with one another, but when put together, they form a logical whole.

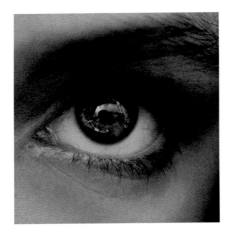

Two elements—an eye and fish—are combined here. Because my eyes are blue, the association with the sea was an obvious one. And fish swim in the sea.

I come up with most images spontaneously, on my bike or in class. I'm always creating, I'm always alert. Sometimes, I really sit down to work out a concept because I feel the message is important and want to have the idea clearly worked out.

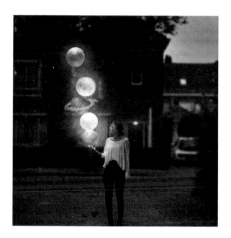

I always seek out separate subjects and then combine them.

In some cases, I also create a sketch, partly as a reminder, but also if I want to try out something new and want to check whether the composition is right, whether it works.

I look for a link between separate subjects and objects. How are they related? I don't want to include a lot of my emotions in them; the viewer must be able to see what they want to see and experience whatever memory or feeling the photograph evokes for them. I don't tell the whole story—I want to inspire. The image is therefore objective, but it can reveal my opinion.

HOW TO... **IMAGINE**

+ Think about what objects you're going to combine. It's best not to combine more than two or t three main elements. Make sure that the idea is clear and understandable.

+ Once you have an idea, leave it to settle for a day!

+ Think when you're going to do it: sometimes you need a lot of time for the shoot, and sometimes it's the editing that's time-consuming.

+ Is the concept totally clear in yout mind now? Then work out the details: think about aspects such as setup and pose, lighting, makeup, and clothing. How should the surroundings look? What pose works best? Do you want eye-catching, dramatic makeup? Do the clothes play an important role?

+ Possibly make a sketch.

+ Only then should you start photographing. Keep the image simple. Make sure that background elements don't distract from your chosen subject(s). Read more about taking the photos in the Shoot chapter.

+ In order to produce good work, you must be prepared to examine your resulting image critically. Could it be better? Then have another go!

Just do it!
All the experiences I have are incorporated into my photos later. I've done so many weird things for my images. I virtually live in parking garages, because I find them so fascinating, and I watch the sunset from the same spot every evening. So, gain experience, in everything.

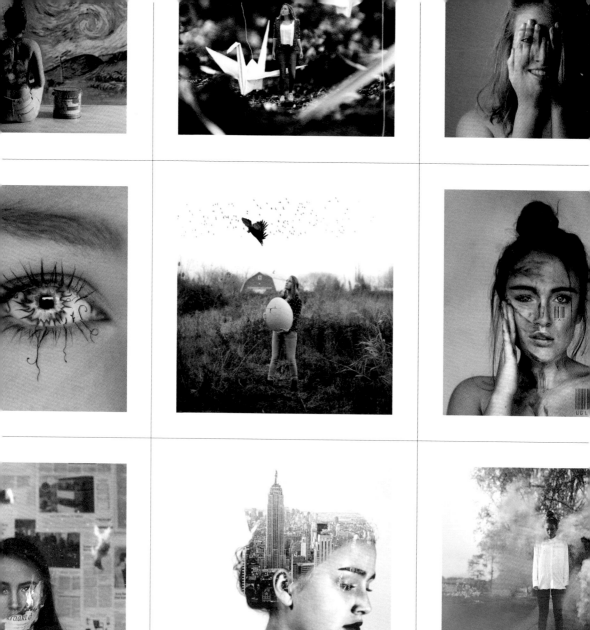

SHOOT

SHOOT

Once you've thought of and developed the concept, you can start photographing. If you keep the photo simple, it's easier to make the end result look realistic. A simpler image needs less editing and is also easier to edit. Contrary to what many people think, my photos are 90 percent real and 10 percent edited.

Camera, lights, action!

You don't need a lot to start photographing: a camera and light. You should also think about the location and the setting and before you begin, you can ask yourself a number of basic questions about focus and precisely what photographs you need in order to produce your final image.

Camera

You really can take photos with any camera – it's not about the camera. I now have an SLR, but I started with an iPod. It might not offer that many possibilities, but it gives you a chance to try out whether you actually enjoy photographing and editing. For a very long time, I didn't use a tripod. You can raise and stabilize a camera with a chair and a pile of books. Before you invest in equipment, studio lights, or a flash umbrella, you first need to know what you want to create.

Light

I don't know much about the technicalities of photography, and I don't pay much attention to them. Just remembering a few basic rules about light will get you a long way.

- Take a photograph during the day, unless you're looking for a night effect. Everyone has daylight, and it's free.
- Make sure that the object you're going to photograph is clearly lit. So, photograph near a window or outdoors.
- Preferably don't take photographs in bright sunlight. The brighter the sun is shining, the more shadows you'll see. That makes editing harder.

– Which way is the light falling? At firs,t I paid little attention to
 how the light was falling—from the side, from the front, from
 above. Look carefully at what you're seeing, and what you
 want. Where do you want shadows, and where do you
 want highlights?

Location

In order to take your photos, you also need location: a spot where
you can create the image that you have conceived. Often you'll
have a suitable place in your home, but you can also go outside.
Ideally, you should take your photos in a peaceful environment, but
you can also choose to go and stand in the middle of a shopping
center. I find that very awkward, but if you need to do it, just don't
pay any attention to the people around you. You may not find the
ideal location easily, but explore whether some simple adjustments
can make a space suitable for your photo, and bear in mind that
you can always remove something in the edit, such as an intrusive
lamp post or tree.

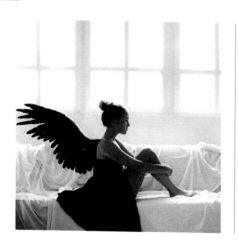

Sometimes you can even create a
different setting with some simple
aids. For this photo, I hung sheets
in the living room; for another, I
stuck up newspapers all over
everything. Doing something
strange for a photo often makes
the image cooler.

Clothing

I never really wear complicated clothing in my photos. Black trousers often disappear against many backgrounds, so that's a no-go, but otherwise I just wear the clothes that I would wear to school. Clothing and make-up do not contribute anything significant to my images. I want to show the unusual aspect of normal things, create surprising combinations between very ordinary and recognizable things.

I have my hair in a knot in almost all my photos. It's easy, requires little attention and you don't have to cut each hair out of the background during the editing. It seems that people also like to be able to see my face: my photos with a knot almost always get more likes than those with my hair loose.

Here, the dress is black because it contrasts with the white snow. But apart from that, the dress is not important.

I WANT TO SHOW THE UNUSUAL ASPECT OF NORMAL THINGS, CREATE SURPRISING COMBINATIONS

Where is the focus?

Decide where the focus of your image will be: what is the focal point of your photo, what do you want the viewer's attention to be drawn to? The focal point doesn't have to be in the middle of the photo, by the way! Everything must be clearly visible and well-lit at the focal point.

The camera's position, the spot from which you are photographing, must fit with your concept. A portrait is generally not taken from above, and it's better to photograph silhouettes from a low position. The ideal setting doesn't exist, but your position can help. Make sure that the horizon in your photo is more or less straight. Unless you want to play with it, of course.

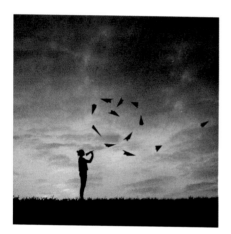

If you only want to see a sharp silhouette against the background, like here, and no intrusive buildings or other elements in the background of your photo, a low position is handiest. So place your camera close to the ground.

ALWAYS TAKE EXTRA PHOTOS OF THE BACKGROUND. THAT ALLOWS YOU TO ADD EXTRA SPACE, SKY, SEA, WALL, ETC. TO AN IMAGE.

How many photos do you need?

The fact that you're combining two subjects does not mean the you only need two basic photos for your final image! You must think about every detail, and preferably photograph them separately. You can then zoom in on the details, and that way, you retain the best quality, even if you later enlarge or reduce that element for use in your final image. If you shoot the whole image in one go, a detail that turns out to be important later can be out of focus or in shadow. So sometimes you may need five different photos!

Two photos of the same place but with and without a subject give you the opportunity to play. For example, if you're taking a portrait in the kitchen, also photograph that kitchen without the person in it. Suppose you want to remove their head. Now you can; you also have a photograph of what was behind that head.

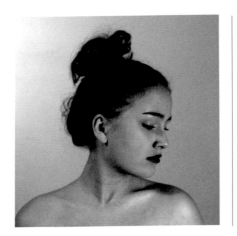

Don't just think about selfies—
also use the self-timer on your
camera or phone!

Self-Portrait

All my photographs are really based on a self-portrait. To do that, you can't keep the camera in your hand like with a selfie—you use the self-timer. You also need a spot where you can place the camera, like on the bookcase, a chair, or a tripod. The tricky thing about a self-portrait is that you cannot see in advance how the light will fall or exactly where the focus is. You want the focus to be on you, but you are not yet in the shot. Nor can you see where shadows and highlights will fall. The tricks listed below make it easier, and apart from that, it's all down to practice! Time after time after time... Just hang in there!

- Look through the camera at the point where you're going to sit or stand, and hold your hand in shot as far away from you as possible. See how the light falls on your hand. Try to predict the shadows and highlights that you will see.
- If you're photographing with autofocus (for example, with a phone), set the self-timer and place a chair or stuffed animal or something similar in the spot where you're going to be standing or sitting. The camera can focus itself, and the focus will not change. Press the self-timer and take the object's place. You need to do this again for each photo you take.
- If you're able to use manual focus, also use an object instead of yourself, but set the focus manually. You can store this setting for all your subsequent photos, so it saves you lots of work!

Internet Image

I don't just use images I've photographed myself, but also images from the internet. Look for an image on the internet which is in the public domain or has a Creative Commons license. (You can't simply use someone else's copyrighted images.) There are photographers who indicate whether and how you may use their images, for example with a credit, and there are also stock agencies where you can download royalty-free images (sometimes you have to pay for this).

When using photos from the internet, pay attention to the resolution. If the image has a low resolution, the resolution of your own photo will also decrease; this is equalized for all the images you use. The lighting in the photos that you get from the internet is always different from the lighting in your own photo. You will have to adjust that in the edit.

HOW TO... **SHOOT**

+ Draw up a step-by-step plan on the basis of your concept and the research that you have done into details such as setup, lighting, makeup, and clothing: what things do you need to get the shot?

+ Think about what setting is the most suitable for taking your photo. See whether you can create the ideal setting yourself.

+ Don't be put off by people looking at you or thinking what you're doing is strange or funny.

+ Take lots of photos, and always take extra photos of the background.

CREATE

CREATE

Using the photos you've taken, you're going to put together the final image that you have developed as a concept. You'll edit the photos into one that looks logical and natural—and with a touch of magic here and there.

AS THE MAKER, YOU'RE
IN CONTROL.

There are a lot of different apps for editing photos. Personally, I use **Superimpose** and **Deforme**, but you can also use other apps or Photoshop; the basic techniques are usually the same. Photoshop offers the most possibilities, but that is not necessarily an advantage, particularly when you're just starting out.

In the beginning, I wanted to do much too much, with all sorts of complicated effects in which the surroundings also needed to be modified, including the light on my face and the backdrop. I thought that I could add atmosphere with extra filters, but they actually removed it. The strength of my photos lies in their originality. The same will be true of your images, too.

It's easier than you think to trick people with a photo. As the maker, you're in control. With a play, for example, you don't notice if the actor makes a mistake as long as they don't draw your attention to it. I can point out in my images what's fake, but it's not difficult to create images that look real. Keep it simple.

BASIC EDITS

1. Expansions

You often need this technique, and in many cases, it's also what you start with. You often want your final image to be larger than the main photograph that you've taken. You start with a blank background, the canvas on which you are working, that is larger than your main photo. Now place that photo in the spot where you want to have it, and around it, you fill the canvas with (parts of) the photos. This is what you need those extra photos of the background (sky, wall, grass, sea, etc.) for. You can choose a blank background in the app under **Import background → Pick color.**

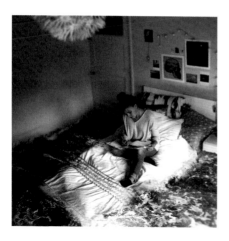

For this photo, I created an expansion: The main image of myself on the bed was not big enough at the top and on the left-hand side of the photo, so I added some image there. On the right, I also added some water.

———

MASKING IS A DRAG, TO BE HONEST. SOMETIMES YOU CAN SPEND AN HOUR AND A HALF DOING IT!

2. Cutting or deleting

This is the easiest and probably most frequently used technique, as you will almost always want to cut something out or delete it. You can do that in various ways: in the two layers individually, or in the merged image. You can find various tools to do this in the apps under **Mask.**

It's best to cut out the image by zooming in to pixel size. You can then carefully remove pixels. That way you outline the image that you want to keep. Check that you really have removed everything: Move the cut-out image to and fro over the foreground and look at the edges. Sometimes you will see something else you need to get rid of.

3. Strengthening Layers or Leaving Them Out.

With this edit you can choose which layer from the image you want to bring out or fade. There are various settings to choose from, and you can find them in the apps under Transform. I often use the following:
- **Screen**: You only keep the highlights, no shadows.
- **Multiply**: Only the black tones/shadows from the layer are strengthened.
- **Overlay**: Highlights and shadows are strengthened, contrast in the photo increases.

There are often more options. Give them a try, experiment.

4. Color Adjustment

You can also adjust color and exposure in your photos in various ways and at different levels. In the apps, you can find the options under the **Settings** for **Transform** and **Filters**.

- Is the lighting on the photos different, so one is darker or lighter than the other? You can adjust that using **Exposure**, **Brightness**, and **Contrast**.
- Is a particular color dominant in one of the photos? For example, is a photo too red? You can change this by adjusting the **Hue**, color tone. You can do that for a whole photo, but also for just a part of it.
- You can adjust whether your colors are rich or faded with **Saturation**.
- If the midtones on the photographs don't match, you can adjust the settings for the various color layers (**cyan, magenta, yellow**). The midtones are not the shadows and not the highlights, but the tones in between.

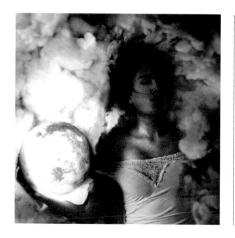

With this photo, the light was coming from the left, on the face and chest. So both light and shadow have been added on the left, to add depth and make things look natural. Generally speaking, light does not come without shadow.

5. Adding Depth

In order to make your image more realistic, you can add depth. You can do this by applying shadows, but also by varying the dark and light parts of your image and by playing with focus.

If you don't have much experience and are not sure where the shadows should be, you can use Drop Shadow in the apps: this function automatically adds shadow. Check the effect carefully—it doesn't always do what you want. The box on the next page explains how to add shadow effects yourself.

HOW TO... **ADD SHADOW**

+ Load a photo of a black surface as the foreground.

+ Mask: Remove all the black, and only add it again where you want shadow.

+ Possibly make the shadow a bit softer (less dark) by adjusting **Opacity**.

6. Distortion
I distort part of a photo in a separate app like **Deforme**, but you can also do it in Photoshop. I don't use this technique often, but sometimes you need it, like I did to distort the gum bubble in the photo below.

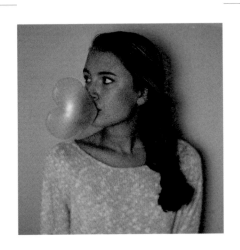

7. Color Adjustment

Finally, once you've finished working on the image, you can apply a color adjustment. This can be done in Instagram itself, or in other apps. You can use one of the provided filters for this or adjust the color nuances yourself (**Hue** and **Saturation**). This final addition often makes a big difference: the photo may become more unified or clearer, for example. In order to be able to work well with these techniques, you need to practice a lot and look carefully at the various effects. I didn't know how to do it right away, either!

8. Collage

You can use separate apps, such as **Layout** from Instagram, to combine multiple photos into a collage. Sometimes this option is also included in your editing app.

Smooth Transitions

Combining images must be subtle in order to make it appear as real as possible. Transitions must therefore be smooth. You can do this by blurring the edges of the cut-out image (**Blur mask**) or by brushing over the edges with a soft brush, but also by matching the colors. If I hadn't changed the color of the water in the photograph on page 27, it would have been much more obvious that it was a composite image.

HOW TO... **CREATE!**

+ Keep it simple, including in the editing.

+ Don't add any complicated shadows. Your image is often more realistic without.

+ Remember that every layer means an extra loss of quality. Get the maximum out of the minimum.

+ Try out the various options in your app or program: you need to learn to play with them and see what they do to your photo in order to know how you can use them.

Have fun!

LIST OF **TERMS AND ACTIONS**

The actions and terms listed below appear in most apps. Sometimes they are somewhere else in the app or have a different name, but the basics are the same for almost all apps.

Filter → **Settings**: You can adjust colors, lighting, and sharpness for an image here. In Photoshop, this element is called **Adjustments**.

Hue: color tone.

Saturation: color saturation. If you set Saturation to 0, you will have a black-and-white photo.

Exposure: You use this to make the highlights in the photo darker or lighter.

Brightness: makes the shadows darker or lighter.

Contrast: adjusts the contrast between highlights and shadows. In a black-and-white image, whites will become whiter and blacks will become blacker.

Blur radius: blurs the entire image. You can often choose from various options: blur from center, only the sides, etc.

Import foreground/background: Here, not only can you choose which photos you want to import, you can also load a blank canvas if you want to do an expansion.

Import foreground/background → **Pick color**: Choose the color and size of the canvas on which you're going to do your expansion.

Mask → **Settings**: Here you can find the various tools for cutting, or removing parts of your image. There are often many options, including:
- **Brush or Eraser**: You can modify the shape, size, and smoothness of these.
- **Magic wand**: delete everything that is one particular color. For example, if you click on sand, all the sand in the photo will disappear.

Other useful Mask functions:
- **Blur mask**:Yyou can set the **Blur radius** here in order to determine how sharp the edges of the cut-out image are.
- **View mask**: You will see only the layer (foreground or background) in which you are working, so you can see more clearly what you're removing.

Merge: Combine the foreground and background into one layer. You can then combine this image with other foreground or background images, which you can then also merge, etc.

Merge and save: If you save the merged image as you work, you can always go back to that earlier stage of the edit later. Watch out! You lose quality with every merge.

Drop shadow and merge: Here, you can choose to automatically add shadow.

Transform: distortion; change the size, orientation (horizontal/ vertical), or proportions of the image.

Transform → **Settings** → **Opacity**: adjusts transparency. Also handy if you want to see the foreground and background when editing with Mask.

Transform → **Settings** → **Blend mode**: certain layers from the foreground or background photo are emphasized or removed. Multiple option,s including:
- **Normal**
- **Multiply**: shadows (blacks) are emphasized; the photo gets darker.
- **Screen**: only highlights are emphasized, no shadows; the photo gets lighter.
- **Overlay**: highlights and shadows are strengthened; contrast in the photo increases.

With each photo in this chapter, you will find an indication of the time it took me to create the image. Sometimes you need more time for the shoot, other times it's the editing that takes longer. As you will see, it's variable, and when you begin, it may take a bit more time, but who cares? It's worth it!

HOW TO

IMAGINE

This was a quick idea and was not difficult to create. It took me about two hours to produce. I am very afraid of heights, but I like to do things in my photos that I wouldn't dare to do in real life. What would be the most awful thing for someone with a fear of heights? To float over a city like this on a swing!

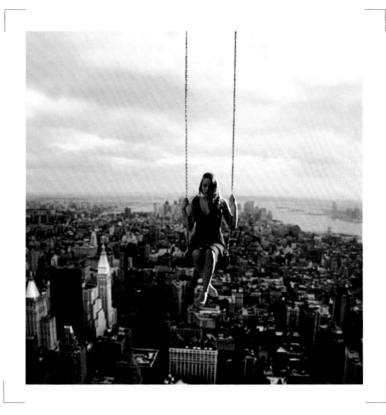

NY SWING

SHOOT 10 MIN **CREATE** 60 MIN

—

OPT FOR A CLEARLY
VISIBLE EMOTION, OR
NO EMOTION AT ALL. A
KIND OF "SMILING FOR
THE CAMERA" DOES
NOT HELP YOUR
CONCEPT.

—

SHOOT

The background image of the city comes from the internet. In the
foreground image, I photographed myself on a real swing. You
could also use a couch or chair to pretend you're sitting on a swing
and add a picture of a swing later, but it's difficult to get that right.

Initially, I wanted to sit with my back to the camera, but that turned
out not to work: you don't recognize the swing as a swing when it's
composed that way.

CREATE

+ Load the photo of the city as your background.

+ Load the photo of the subject in the swing as your foreground.

+ Determine the position of the photo on the foreground: where should the swing be hanging?

+ **Transform** → set **Opacity** to 50% so that you can see the foreground and background. Onc you've chosen the position, set the Opacity back to 100%.

+ **Mask**: Cut out everything from the foreground photo that you want to remove so only the swing remains. Make the image separate so you can place it on any background. This takes quite a lot of time!

+ Adjust the lighting: Check whether one of the photos is much darker or lighter than the other, and adjust the lighting (**Brightness, Exposure**) so tha they match. Do the same for **Contrast** and **Saturation**.

+ **Merge** and save. Finished!

IMAGINE

I created this image in the summer of 2015. I had the simple idea of allowing the sea to flow over me like a blanket. A while later the photo of the washed-up Syrian refugee boy appeared in the media. My image was widely shared, and its topicality gave it an emotional charge. I find it strange to see this photo from back then again. You can see the resemblance to the photo of the boy, while my image had such innocent intentions.

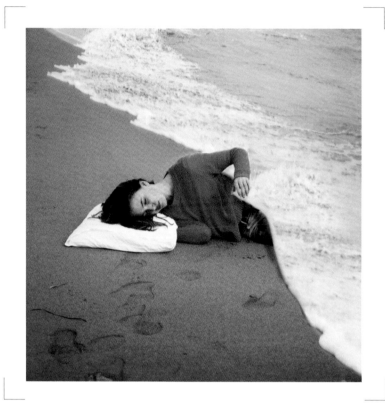

CHILDREN OF THE SEA

SHOOT 25 MIN **CREATE** 45 MIN

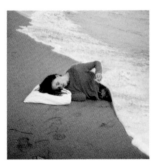

SHOOT

Two photos: one of myself lying on the beach (with a pillow!) and one of the beach.

CREATE

+ Load the photo of your subject as the background.

+ Load the photo of the sea as your foreground.

+ **Transform**: Set **Opacity** to 50% so that you can see clearly what you're doing. You want to place the edge of the sea in the foreground diagonally over the photo. To do that, you need to distort the photo in the foreground, and in this case, reduce the photo of the sea and stretch it vertically.

+ **Mask**: Remove the sand from the photo in the foreground. That's easy, because the sand is the same color everywhere. You can use the Magic Wand to remove it in one go.

+ **Mask**: Carefully use the **Brush** to remove everything from the image in the foreground that falls on your hand (it needs to hold onto the sea blanket) and on the arm that will be on top of it.

+ **Transform** → Restore **Opacity** to 100%.

+ **Merge** and save.

+ Now you can also add shadow under the arm and leg: Load a photo of a black surface as foreground.

+ **Mask**: Use **Brush** to delete everything, and then add a little bit of shadow back in with a soft brush.

+ **Transform** → **Opacity**: Adjust if required so that the shadows become softer.

+ **Merge** and save. Finished!

IMAGINE

Usually, a concept consists of two ideas that I link together, but in this case, it was more of a dissection: I broke the concept of a "trending topic" into two elements. The symbol for trending on YouTube and Twitter and the like is a flame. The newspapers stand in for all media. So I converted myself into a trending topic.

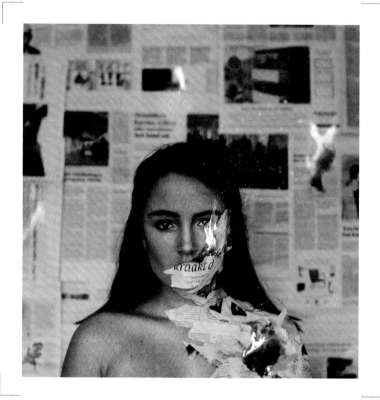

TRENDING TOPIC

SHOOT 45 MIN **CREATE** 25 MIN

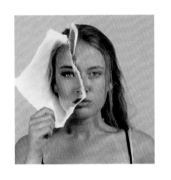

Add Color

Most editing apps do not offer you the option to draw or paint on your photo with colors, like you can do in a program like **Paint**. If you want to add colors, such as black shadow, you do that by loading a photo of that color as the foreground and removing that color everywhere (**Mask**) except where you want to retain that color. You can find a photo of a colored surface on the internet (try searching for "photo colored surface" in **Images**).

SHOOT

This image is more real than fake! I stuck newspapers on the wall. I could have inserted the background behind it, but then I would have had to have cut out every hair and detail in the foreground separately. This is easier, and the shadows of the layers of newspaper on top of one another lend a nice effect. In order to ensure that the newspapers on my face and body could move with me, they had to be small pieces. I just stuck those on with a glue stick, but I'm allergic to the gluten in glue, so in hindsight that turned out not to be such a great idea!

I wanted to create some continuity through the image, like the foreground newspaper camouflaged me against the background. To achieve this, I posed myself very close to the background. In order to ensure that the fire still stood out, I chose a depth of field so that the background is less sharp (and therefore darker) than the foreground. If you can adjust it, opt for an aperture setting of $f/1.4$ instead of $f/2.8$.

The photo of the fire came from the Internet: a clear flame without dark shadows, with a dark background. So that I could add black, I also needed a plain black photo from the internet.

——

CREATE

Because I had already done so much in the photo itself, the editing of this image was minimal. First, I had to ensure that the fire was realistic, with dark edges and spots, like paper or newspapers that are burnt and charred. The flames themselves are highlights, and you can't see a highlight on top of a highlight, so you need a dark backdrop.

+ Load the photo with newspapers as your background.

+ Load your black photo as the foreground. The **Opacity** must be around 70% so you can still see through it.

+ **Mask:** Use the **Brush** to remove all the black, and add it back in with the **Brush** or **Eraser** where you want to create a black backdrop behind the flame.

+ **Merge:** Merge the background and black spots. Also save this image as you work.

Bonus edit!

+ I thought it would be nice to add some extra sparks to this image. To do this, use a photo of a cloud of sparks against a black background. When you load that photo and set it to **Screen**, the black background disappears, and you're left with just the sparks. You can then position them in one go in the place where you want them.

+ You can now add the fire.

+ Load the flame photo as your foreground.

+ **Transform → Screen:** All shadows disappear from the photo, and we're just left with the flame.

+ If some of the shadows around the flame have not gone away, adjust the **Brightness** and **Exposure** in **Filter** to make the flame more intense and to make the backdrop more or less present.

+ **Transform:** Position the flame in the right place. Repeat these steps for every flame you want to create.

+ **Mask:** You can remove any small details here.

+ **Merge** and save. Finished!

IMAGINE

Sometimes I want to include a message in my photo, and this time I wanted to do something with Pride Month. The image of a rainbow is a bit of a cliché, but in this case I think it's allowed because it is an important visual symbol. Viewers understand what it means when they see it.

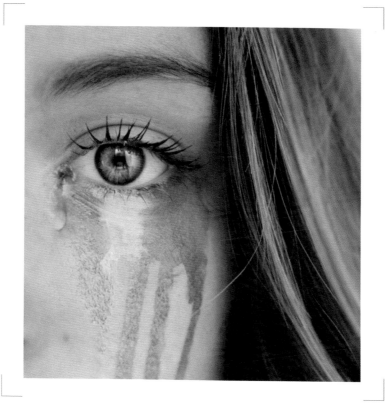

RAINBOW EYE

SHOOT 5 MIN **CREATE** 2 MIN

 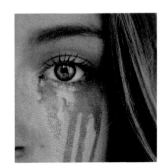

SHOOT

Everything about this image is real apart from the rainbow colors in my eye. Good lighting is important—taking a good photo of your eye is harder than you think because of the shadows that fall on it. It's best not to stand too close to a window, but to be near it. If you're too close to the light source, the contrast becomes too great. You don't want bright sunlight, but an even light source about three feet away. You take the photograph from very close.

Makeup is always fun! In this case, I used paint—paint is not necessarily good for your skin, and if you're going to do this, check that it's not harmful first. I placed a spot of paint in each color under my eye and used my fingers to drip water onto them as though they're tears.

When you photograph your eye, it's difficult to see where the focus is. You want to keep it on the iris and not on the eyelashes, for example, so you retain the details of the eye. You just have to keep trying until you succeed.

For the colors in the iris, I used an internet photo of a circular rainbow. You can try out different effects too—see the photo opposite for some inspiration!

CREATE

+ Load the photo of your eye as your background.

+ Load the photo of the rainbow as your foreground.

+ **Transform** → **Overlay**: Shadows and highlights are clearly accented in the foreground.

+ **Transform**: Reduce the size of the rainbow image so that it fits precisely on the eye.

+ **Mask**: Remove all of the foreground outside the eye.

+ **Merge** and save. Finished!

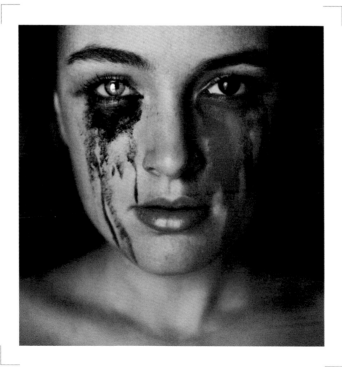

IMAGINE

I was at the beach for a week and didn't know what to do with myself. So I got photographing! You can make really good silhouettes at the seaside, and I wanted to do something with nighttime. That became the moon. I saw lots of fishing nets lying on the beach, and that gave me the idea of a butterfly net to capture the moon.

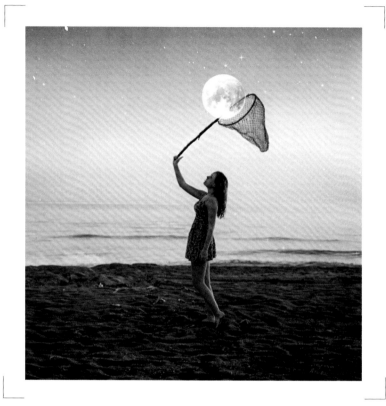

CATCH THE MOON

SHOOT 30 MIN **CREATE** 30 MIN

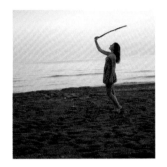
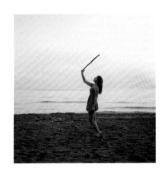

—

IF YOU CAN
PHOTOGRAPH
SOMETHING FOR
REAL: DO IT!

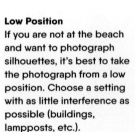

Low Position
If you are not at the beach
and want to photograph
silhouettes, it's best to take
the photograph from a low
position. Choose a setting
with as little interference as
possible (buildings,
lampposts, etc.).

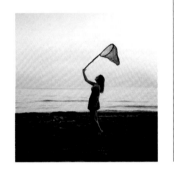
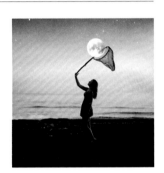

—

SHOOT

The photo was taken at sunset. You can also fake that, but it is much
trickier. I didn't have a real butterfly net, but I had to be holding
something in my hand, so I used a stick. I needed a faraway
silhouette, but I took a photograph of myself from nearby, so the
quality is better, and then expanded the area around my form later.
I also took extra photos of the sky. The butterfly net and the moon
came from the internet.

CREATE

+ **Expansion → Import background:** Load a blank canvas with the size you require.

+ Load and position the photo of the sea at the bottom of the canvas. You're going to add extra sky at the top.

+ **Merge** and save.

+ Load photo of the sky as foreground and position, placing it at the top of the canvas.

+ **Mask:** Remove the part of the sky that you don't need.

+ If the transition between the extra sky and the sky in the background is not smooth:
 Mask → Brush: Use this to brush over the edges in order to make the transition smoother.
 Blur mask: Blur the edges of the foreground photo.

+ If the photos are too light or too dark, adjust **Brightness** and **Exposure**.

+ **Merge** and save.

+ Load the butterfly net as your foreground. I chose a photo with a dark butterfly net and a light background.

+ **Transform → Multiply:** Shadows are accentuated, so only the butterfly net remains.

+ Position.

+ **Merge** and save.

Load the photo of the moon as your foreground. Adjust the position.

+ **Transform → Screen:** Accentuate highlights.

+ **Merge** and save: finished!

IMAGINE

It was the first day when it was really cold outside, and I'm always fascinated by those clouds of steam that we breathe out. I wanted to clearly depict that phenomenon, preferably in 3D, and I had the idea of doing this with white cotton balls. Against a white background they would disappear, and I didn't think a dark background was right, so I chose the color combination of pink and blue. In my experience, lots of people find that a pleasant combination to look at.

I made the cloud out of cotton balls that I already had in the house. There are only about five, duplicated ten times. I often buy crazy things that I think I can use later for my photos. It's fun to make something like this cloud yourself. You create the structure yourself, and you can never reproduce those shadows! With a fake cloud from the internet, the image would have become much shallower, much less realistic. I like playing with that effect where people think it's not real.

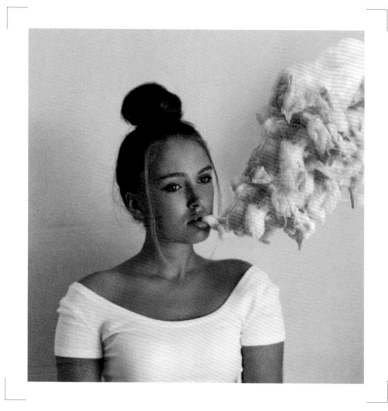

PINK CLOUDS OF PARADISE

SHOOT 30 MIN **CREATE** 25 MIN

Fake Shoulder
If you look carefully, you can see that my left shoulder is a mirrored copy of my right shoulder. I had forgotten to take a photograph with my arm down the the way it needed to be in the final photo. Always remember to take that extra photo—it's easier and the end result is more real!

SHOOT

The light in this photograph had to come from the side. If it was lit from the front, I would lose too many shadows. Side lighting doesn't have that effect. The shadows are what create the 3D effect here.

In order to have the cloud come out of my mouth in a natural way, I had to actually put it in my mouth. So in this case, I had to take at least three photos: one with the cloud in my mouth that I'm holding onto (because it needs to go upward), one of the same pose but without a cloud (arm down), and a close-up of the cloud.

CREATE

+ Load the photo without the cloud as your background.

+ Load the photo with the cloud as your foreground.

+ **Mask**: Remove everything from the foreground apart from the mouth and a very small piece of cloud.

+ **Transform**: Position the mouth and piece of cloud in the right place, adjusting the size if necessary.

+ **Merge** and save.

+ Load the photo of the cloud.

+ **Transform**: Enlarge it to a size that fits well with the piece of cloud coming from the mouth.

+ **Mask**: remove everything around the large cloud in the foreground image.

+ Adjust the **Brightness** and **Exposure** if necessary.

+ If the cloud isn't big enough, you can load more copies of it and position in a repeating fashion. Vary the size and positioning—if you repeat the cloud several times in exactly the same way, it will be noticeable.

+ **Merge** and save. Finished!

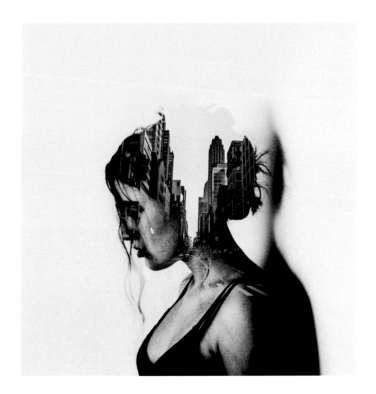

IMAGINE

Double exposure is a commonly used technique where you mix two images, like in the examples shown here.

The combination of a head with another image means you can show ideas or thoughts clearly. In this collage of two portraits, I have placed two different personalities alongside one another —two sides of the same person. One side is about what people expect of me: that I'm very sociable, someone who enjoys company. But I'm also very happy by myself; I like peace and quiet. You can see that contrast here. I don't specify that in the title or the caption—I want the viewer to think about themselves. It's not about me personally.

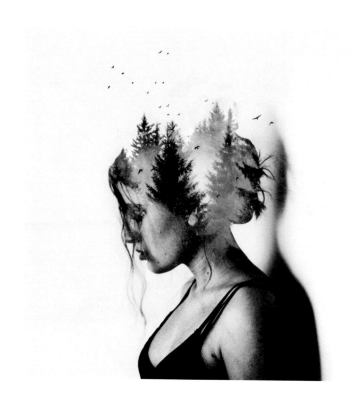

DOUBLE EXPOSURE

SHOOT 15 MIN **CREATE** 15 MIN

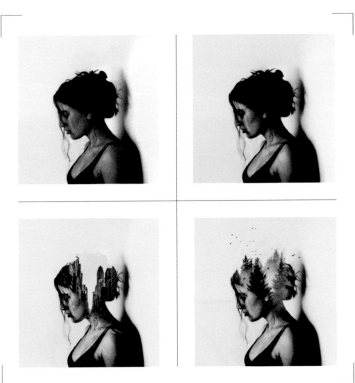

SHOOT

You need to work out this idea carefully in advance. The highlights and shadows in the portrait must fit well with the other image. In particular, you need highlights on your skin, so you can touch up your eyes, eyebrows, and lips with makeup. That will make them stand out better. The background doesn't necessarily have to be white, but it does have to be at least a light color. You will be using the image in black and white later, and then the background will become white. Images of mountains or a city often have sky at the

top. That will disappear against the background, and loose hair will then quickly give the effect of a crown on your head. If you put your hair up, it follows the movement upwards.

Secondly, you need a photo from the Internet. Landscapes make a nice contrast with the portrait. The sky in that photo must be light.

CREATE

+ Load the portrait photo and set the **Saturation** to 0: the portrait now becomes black and white. You might raise the contrast so that the background is as white as possible.

+ Save!

+ Load the black-and-white portrait as the background.

+ Load an image chosen from the internet as your foreground, and convert to black and white if necessary.

+ **Transform** → **Lighten**: All the shadows disappear, and highlights are leftover (the difference from **Screen** is that the highlights become slightly stronger).

+ Position and enlarge or reduce. Use **Mask** to remove parts that are not needed.

+ **Merge** and save.

+ Again, load the black-and-white portrait that you saved previously as the background, and combine it with another image that you have chosen from the internet in the same way.

+ Make a collage of the two portraits.

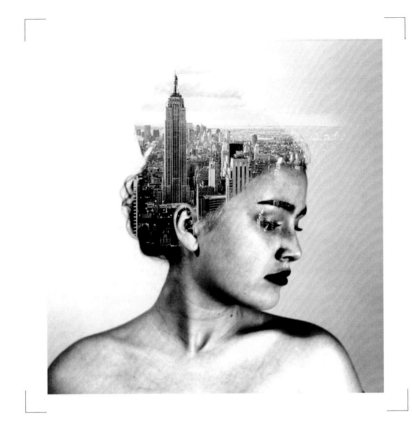

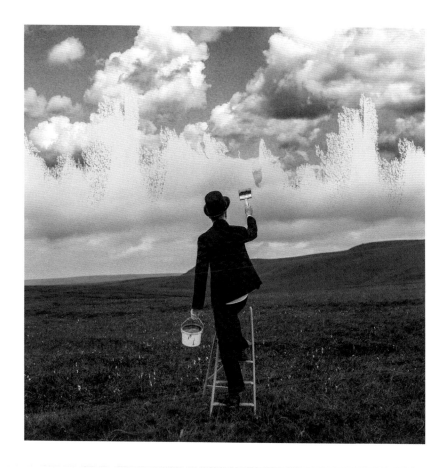

adambirdyy

ADAM BIRD ENGLAND **93,500 FOLLOWERS**

Adam doesn't always do self-portraits. His edits are very realistic and done very well, with shadows and color adjustments and so on. He manages to make concepts appear realistic that I couldn't do. He also does a lot of real stuff for his photos, and I always like that. And he creates a good atmosphere in his images using color (often using faded shades).

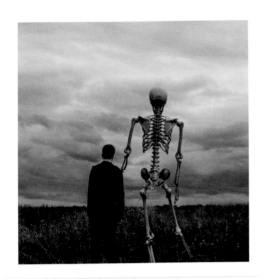
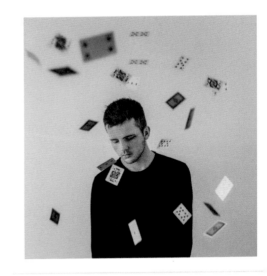
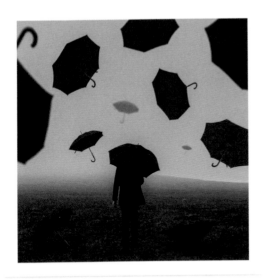
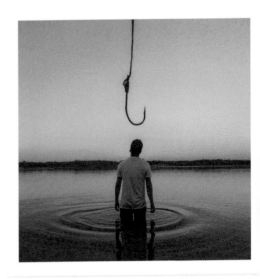

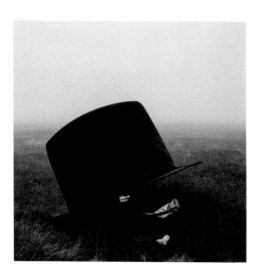

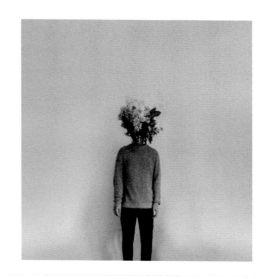

IMAGINE

I made this image after terrorist attacks had occurred in Paris. I don't express myself politically in my images, but I do give my opinion of these sorts of events from my personal perspective. My intention here was to represent the world and humanity as an individual: people are the world and the world is people. There was a lot of anger in the media, but I didn't want to work from that emotion, and I looked to sadness, which I have conveyed with the color blue, and reinforced with a tear.

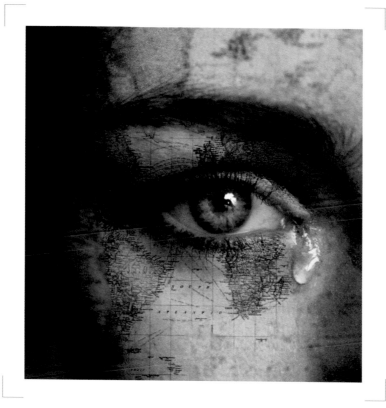

HUMANITY

SHOOT 5 MIN **CREATE** 5 MIN

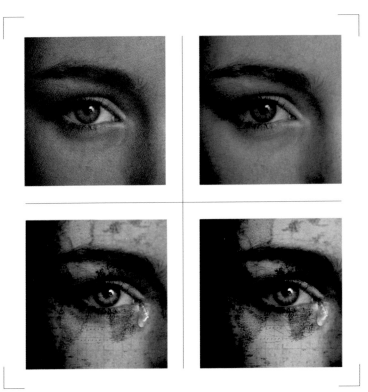

SHOOT

In order to create depth, I stood very close to a studio light (you can still see the light in my eye!), which enhances highlights, and also gives darker shadows, particularly around the edges of the photo. The image of the world map came from the internet and did not have a blue background.

CREATE

+ Load the photo of your eye as the background.

+ Load the photo of your eye as the foreground as well. Set **Hue** to shades of blue. I could also have opted here for a world map with a blue background, but I modified the hue of my face and made it blue instead.

+ **Mask:** Remove everything that has to remain as it is in the original eye photo from the photo of the eye in the foreground. So, the eye, the rim below it, and the eyebrow.

+ **Merge** the foreground and background into one image. Save.

+ Load the photo of the world map as your new foreground image.

+ **Transform → Multiply:** Shadows are emphasized, the countries become visible.

+ **Mask:** Remove the world map where you don't have any blue, so again, on the eye, the space below it, and the eyebrow. Don't merge—you still need to create depth!

+ Save the image in its current form.

+ **Blur radius:** Blur the world map photo and save.

+ Load a photo with an unblurred version of the world map as the background.

+ Load a photo with the blurred version of the world map as the foreground.

+ **Mask:** Remove the center from the foreground, which makes the center of the photo sharp and keeps the edges blurred. In that way, you create the illusion of a round shape, a globe.

+ **Merge** and save. Finished!

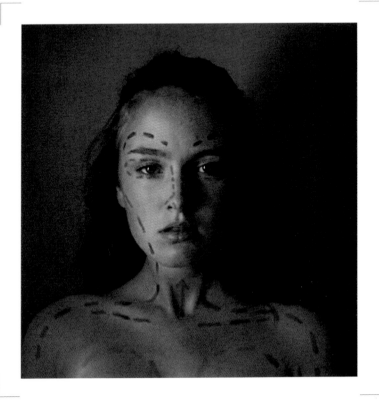

IMAGINE

This image is about the feeling that your body must live up to certain expectations. And not just your body—you can interpret this image in various ways. It's about the lines within which we are confined, which are drawn by ourselves or by others. I found that I could execute this concept very well in the photo. It needed virtually no editing!

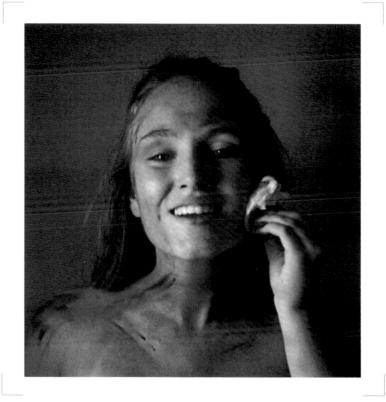

BORDERS

SHOOT 40 MIN **CREATE** 5 MIN

SHOOT

This is the first photo in which I posed without clothes. Clothing is often not interesting, it contributes nothing to the image. But this was a boundary to cross, a threshold, but the nudity serves a purpose here. This photo really helped me. I had concepts that I was not developing because they would require me to show myself naked. After I posted this image, it became easier.

The mood of this photo should not be too "pretty" and the shadows need to be heavy and dramatic. I wanted to show that wiping away the lines (paint in this case) is painful, but also that it makes you happy—that was tricky.

This photo was taken with studio lights in close-up so the background is darker. I had to experiment a lot before the position was right, and then it was very difficult to shoot the wiping away photo with exactly the same light.

CREATE

This image was not edited, completely in keeping with the concept behind it. You just need to make a collage of two images.

IMAGINE

I had had this idea in my mind for a while, and I had worked with fade-out smoke and wings before. Sometimes I don't have much time; that played a role here too. It had to be wet, as if everything was freshly painted, and I wanted a vague, unclear atmosphere.

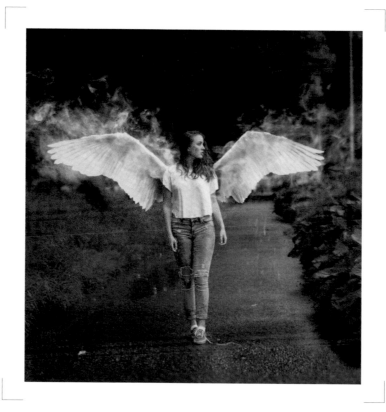

WITH BRAVE WINGS SHE FLIES

SHOOT 30 MIN **CREATE** 40 MIN

THE CLOTHES,
THE LOOSE SHOELACE,
THE LAMP POST THAT
REMAINS IN SHOT...
IN HINDSIGHT, I'M NOT
PARTICULARLY HAPPY
WITH THIS PHOTO!

SHOOT

It was raining very hard! My hair is soaked and I had trouble keeping my camera dry. I had attached an umbrella to my tripod with tape, and brought everything outside. It was a challenge, but it does leave you feeling that you've really worked hard for something!

The photo of the angel wings came from the internet, and had a one-color background. The photo of the smoke, also from the internet, had to have a dark background.

CREATE

+ Load the photo of your subject in the rain as the background.

+ Load the photo of the wings as the foreground.

+ **Mask → Magic wand**: Remove the background around the wings in one go. Touch up with the **Brush** if necessary.

+ **Transform**: Position the wings behind the subject's back.

+ **Transform**: set **Opacity** to 50% so you can see where the back and the wings overlap each other.

+ **Mask**: Remove parts of the wings that you don't need.

+ Finished? Restore **Opacity** to 100%.

+ **Merge** and save.

+ Load the photo of smoke as your foreground.

+ **Transform → Screen**.

+ **Transform**: Position the smoke around the wings.

+ **Merge** and save.

+ Repeat if necessary in order to add more smoke.

+ **Merge** and save. Finished!

IMAGINE

With this photo, I asked myself the question: Where has art not yet
been? I wanted to show art outside its boundaries, literally outside
the frame. In that way, the painting influences the surroundings and
adds something comical. I want to combine the internal and
external worlds, and it occurred to me that it could be done with
water. The contrast between the painted water on the painting and
the splashing water outside it creates a good effect.

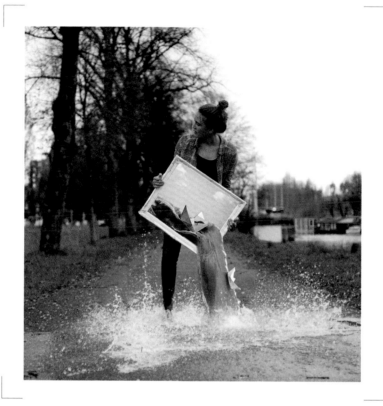

FRAME

SHOOT 60 MIN **CREATE** 30 MIN

SHOOT

This was a really long, fun shoot! I definitely had to take two photos: a photo of myself with an empty picture frame, and a photo of the falling water (that came out of a bucket). The frame had to be tilted so the water would run out of it. To the left of what you see in the photo was a ditch where I could get water, and I had enough room there to play with it. A dark background works best with water, and I had to ensure that I was not standing behind the falling water, but to the side, so that you would not see me through the water. I also needed some image around it, so I started with extra photos of the background. Unfortunately, there was a lamp post in the way!

If you can adjust your camera, it's a good idea to choose a fast shutter speed for a photo like this. That way, you can capture as many sharp details of the water as possible.

CREATE

+ Choose the size and shape (rectangle/square) for a white canvas and load it.

+ Load the photo with the picture frame as your foreground.

+ **Merge.**

+ Load your photos of the sky and surroundings and fill the canvas. Position each photo using **Mask** to remove parts you don't need. If necessary, adjust the lighting and fade the edges with **Blur mask**.

+ **Merge** and save.

+ Load a photo of a painting (from the internet) as the foreground.

+ **Transform:** Position, adjust size, and **Merge.**

+ Load and position the picture of the water cascade.

+ **Mask** → **Brush** → adjust **Smoothness**: Remove anything unnecessary. The transitions between the painted water and the "real" water must be smooth. You need to "cut" fairly closely using **Mask**, but there are so many details on the ground that this is tricky. That's why you can fade the edges there, not with **Blur mask** (that will fade the whole image), but by "stroking" them with a soft **Brush** (adjust **Smoothness**).

+ **Merge** and save. Finished!

IMAGINE

This photo was made for Instagram: When you like the photo, the heart will appear precisely in the middle of the heart-shaped series of paper planes in the photo. This creates an interaction between the followers on Instagram and the image's maker.

My idea was to create a silhouette and to add something youthful to it, so I asked myself what I liked doing as a child. The answer: folding paper planes! If my parents weren't there, my brother and I would stand on the couch and see whose plane flew further. I kept the silhouette small.

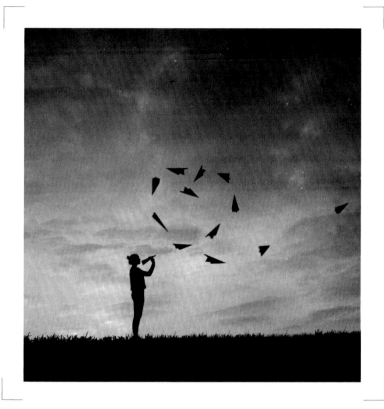

FILL IN THE HEART

SHOOT 15 MIN **CREATE** 35 MIN

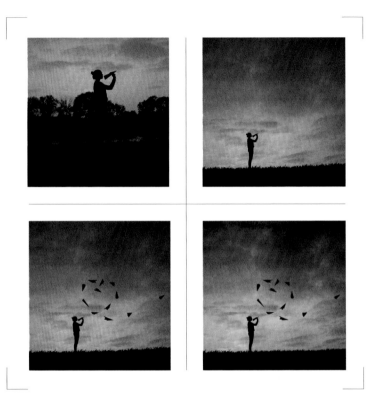

SHOOT

I had this idea in my mind for a while, and I waited until there was a really nice sunset in order to produce a good silhouette. That meant I had the background just where I wanted it and didn't have to edit it. Apart from the grass in the foreground, the image was complete at that point.

The photograph is taken from low down and with sufficient distance so that all of me is in the shot, with a paper plane in my hand. I took a lot of extra photos, including of the sky. I first folded the paper planes, and then threw them in the air and photographed them lots of times. These kinds of photos, of paper planes moving in various directions and positions, are hard to find on the innternet, but they ensure that the photo has depth, becomes 3D. Without those different perspectives, the image can easily become flat.

Maximum Repetition
If you use the same image more than once, like the photo of a paper plane here, you must ensure that you cannot see that repetition (unless that is the intention, of course, and you want to show a series of identical images). You can use the same image about three times before it becomes noticeable. And with repetitions, once you see that some images that have been used more than once, you can suddenly see all of them.

CREATE

+ You'll start with an expansion. Select a color and size under **Import background** for the canvas that you want to fill.

+ Load the photo of the sky as your foreground. Position and load extra sky if necessary in order to fill the canvas.

+ Load a photo of grass.

+ Transform → Multiply: You are left with just dark shadows. **Merge.**

+ Load your silhouette photo as the foreground. Because you have already loaded the sky, you can place the silhouette against the sky/background and you don't have to do any difficult cutting.

+ Transform → Multiply. Adjust **Brightness** and **Exposure**: What works for this image?

+ Position.

+ **Mask:** If disruptive details stand out in your image, like trees or cars in the background, remove them. They can easily make an image look messy.

+ **Merge** and save.

+ Now you can add paper planes. Load your photos of the planes into foreground and arrange them into a heart shape.

+ Transform → Multiply.

+ Transform: Adjust the position and size.

+ Mask: Cut to the required shape.
In order to make sure that it looks like each paper plane is unique, you can also mirror (flip) them and use sharpness/blurring. You can add movement blur to the edges of an image with **Blur mask**.
Arrange your planes into the heart shape.

+ Adjust the **Brightness** and **Exposure**: Make sure that all the shadows are the same color.

+ **Merge** and save.

Quality
Every layer you add and every time you merge them reduces the quality of your image. Red tones in shadow areas are intensified, so the glow gets stronger every time. Look out for this and keep your image simple. You want to get the maximum out of the minimum: achieve the greatest effect without reducing the quality of your image too much. Incidentally, this is not a problem in Photoshop.

If you want to stop this deterioration to some extent, use the first version of your complete image—one where the composition is finished but the editing isn't—together with the edited final version. Using Mask, you can keep the unedited parts that are still as sharp as possible, and combine them with the edited parts from your final image.

Bonus!
The sunset was already gorgeous, but I added extra color and stars to it. The stars make a nice contrast with the dark sky.

+ Load a photo of stars.

+ Transform → Screen. Adjust **Brightness** and **Exposure** so that the stars stand out clearly. You can adjust the colors with **Saturation** and **Hue**.

+ **Merge** and save. Finished!

—

Sticking to the rules does not always get you very far. My school reports used to always say how good I was. I did what was expected of me, but I actually enjoy doing strange things. I became much happier as soon as I stopped worrying so much about other people.

IMAGINE

Often before I fall to sleep, my brain begins to spin. That is really
annoying, but sometimes I get good ideas and think: Wow! I need to
make that image now. That was what happened here. I imagined what
would happen if my pillow flew away, and I wanted to start creating
that image right away.

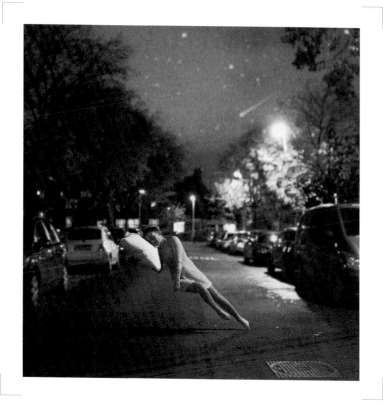

ONE O'CLOCK

SHOOT 30 MIN **CREATE** 20 MIN

SHOOT

I can't recommend this to everyone: I live in a quiet neighborhood, but it was pretty awkward to stand on the street in my nightgown at night like this. The neighbors even came out to look.

The idea of *levitation* is simple: You photograph yourself on a stool against the background, remove the stool, and you're floating. I thought that was too easy, and I wanted it to look more like sleeping, so I took my pillow with me and picked my clothing to match. Taking a photograph in the dark like this is best done with a good camera: it's difficult to achieve high quality otherwise. You also need a tripod or something to stabilize the camera at the shoulder height. There also needs to be shadow, otherwise there is no depth, and it looks like you're lying on the road.

To avoid making things too tricky in the editing, it must be possible to remove the stool completely. It's easier to do that with a skirt or nightgown by hanging it partly over the stool. My pose needed to suggest a flying movement, so I stretched out—just sitting isn't flying! So I was sitting very uncomfortably, and I fell quite heavily once, so take care and make sure you're safe and stable!

In addition to a photo of myself on the stool, I also needed extra photos of the background without me and without the stool.

CREATE

This edit is super easy.

+ Load the photo of the background as your background.

+ Load the photo of your subject on the stool as the foreground.

+ **Mask**: Remove the stool.

+ **Merge** and save. Finished!

IMAGINE

What's unusual about this photo is that it's an image for which there was no concept. There is really nothing behind it. I had an old, failed photo that I still wanted to use, which formed the basis. I was feeling really down, I didn't know where things were going, as if I was looking for something but couldn't find it. In hindsight, this image really does give a good picture of what was going on in my mind.

Once this image was finished, I spent an hour questioning whether I should post it. In terms of nudity, it was another step further, and I know that everyone looks at my images: parents, friends, teachers . . . I always ask myself whether it adds anything to share an image. There are images that I don't put online. Photographs can have a negative influence, including mine. What sort of example am I setting? Sometimes the concept and the image are good, but I still don't post the image.

I once produced an image about narcissism, about being uncertain versus loving yourself. As the extreme of narcissism, you saw Annegien kissing Annegien, naked. The idea of the photo is good, but I felt that the combination of kissing and nakedness was too awkward, so I didn't post the photo. People can easily misinterpret an image.

Often people who feel lost produce dark images, with tears and so on. That's dramatic. This is another way of showing that same quest. And that's why I still decided to post it.

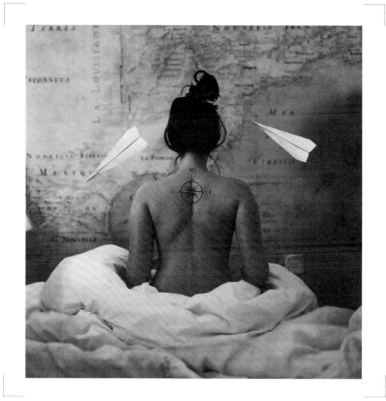

NEW DESTINATIONS

SHOOT 20 MIN **CREATE** 50 MIN

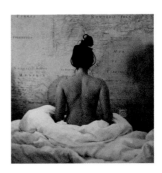
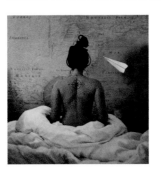
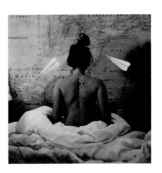

SHOOT

I started out with test shots, to try out the lighting. I wanted my back in the photo, elegant but still edgy as well. I felt unsure about it. In the mirror, you see what your brain sees, but in photos, I see myself as I really am. I'd rather have a photo that I feel good about than a beautiful photo—they're not always the same thing. Sometimes you're smiling nicely in a photo, but if you weren't feeling good at that moment, you still don't think it's a good photo.

As an image for my quest I opted for a map of the world, and as an extra element, I added a tattoo, both images from the internet. I folded the paper planes myself and photographed them separately.

CREATE

+ Load the photo of your subject as the background.

+ Load the photo of the world map as the foreground.

+ **Transform → Overlay**: Only the black lines and country names remain.

+ **Mask**: Remove the world map everywhere that you don't need it. Adjust **Exposure** in order to make the photo display as clearly as possible.

+ **Merge** and save.

+ Add a tattoo: Load a photo of a black tattoo with a white background as the foreground.

+ **Transform → Overlay**. Adjust the position.

+ **Transform → Multiply**.

+ **Merge**.

+ Add paper planes: Load the photo(s) as the foreground.

+ **Mask**: remove what you don't need.

+ **Merge** and save. Finished!

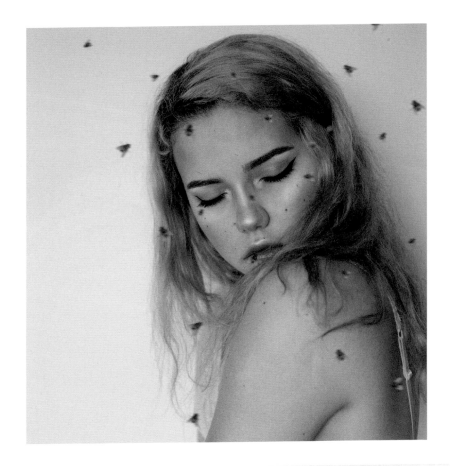

isabellamadrid

ISABELLA MADRID COLOMBIA **93,500 FOLLOWERS**

I wish I had a name like that! Isabella produces self-portraits, and her images have been displayed in places including Times Square in New York and the Louvre in Paris. Her images are atmospheric, and the posing is strong and fits well with what's happening in the photo. She also produces strong concepts and uses simple objects. She is not particularly about the editing, but even without that, there is a lot of feeling in her images. The use of color is a balance between too much and too little. And—sidenote—she has beautiful eyebrows.

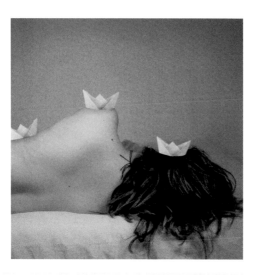

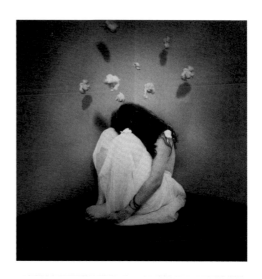

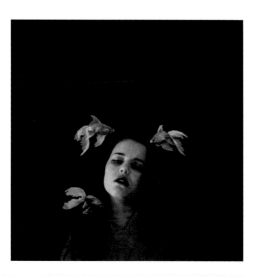

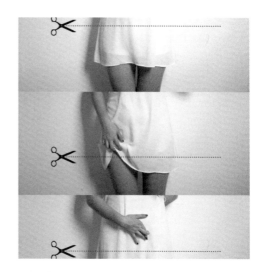

IMAGINE

In this image, I have merged the fluid world of fish with the often less peaceful world of humans. A feeling of water and peace. Although I would totally freak out if fish showed up in my bath in real life!

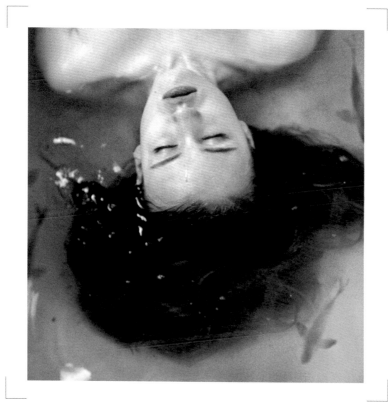

SOMETHING IN THE WATER

SHOOT 60 MIN **CREATE** 40 MIN

SHOOT

In hindsight, this was the most dangerous shoot I've done, and I think "Annegien, how stupid are you?!" My camera was dangling above the water, and right next to the bath was a large studio light. So don't try this at home! Keep it safe and get someone else to take the photo.

It's quite difficult to lie attractively in the bath. Your chin automatically goes up and your eyes go back and your hair doesn't readily cooperate with the mermaid vibe either. It's a real challenge until you get your pose right.

I used paint to color the water, but you can also use milk or one of those bath bombs. Blue and pink is an attractive color combination—like a fairytale.

The fish swim around me like mysterious creatures. You can't show many details of them in the water, so the emphasis is on my face, which is fully lit. The photos of the fish came from the internet and are taken from above. The silhouette, the outline of the shape, must be clear enough in order to be recognizable as a fish.

CREATE

+ Load the photo of your subject in the bath as the foreground and the background.

+ Change the **Hue** of the foreground: The color of the whole image changes. You can play with this until you have the desired color—in this case, pink.

+ **Mask**: Remove what you don't want to keep; just some pink streaks should remain.

+ **Merge**.

+ Load the photo of the fish as the foreground.

+ **Mask**: Completely remove the background around the fish.

+ Reduce the **Brightness** so you're left with just the silhouette of the fish.

+ The fish is *in* the water, not on top of it, so you need to create depth. You can have a fin or some lips poking out of the water. Position and use **Blur mask** to blur the edges of the fish.

+ **Mask** → **Brush**: Use a soft **Brush** to remove parts of the fish where there is a reflection on the water and the fish is underneath it. You can't see the part of the fish under the reflection.

+ Repeat this edit for each fish you add . Don't use the same fish each time, and apply the depth in different places.

+ **Merge** and save. Finished!

Undo
When using **Mask** to remove subtle details, go slowly. Take it step by step. If you remove too much in one go, **Undo** will reverse the whole action, and you have to start again! It's better to work in small chunks.

IMAGINE

This photo is about bullying—in particular, for me, about internet bullying. This hasn't been an issue for me, but I have experienced other people being criticized on the internet. This image was prompted by a post by a girl on Instagram and the negative responses to it. Those comments were just jokes, but they were hurtful nevertheless. With this image, I show how such responses affect you and how you can deal with them.

When I had just started on Instagram, I produced much worse photos and got a lot of criticism. Some people found it irritating that I quickly had so many followers. I took those hate comments to heart. If you're unsure, it's difficult to set aside those negative comments, to "erase" them. You can fade them, though—that's what I want to show.

The irony was that people didn't understand it. They said: "How strange that you've posted this image. You're not ugly, and there's no reason for bullying you, so what are you talking about?" This image is about sticking labels on people, and that was happening again! As if it's OK to bully you if you're ugly, but not otherwise. The idea behind this photo is similar to that of Borders (page 72).

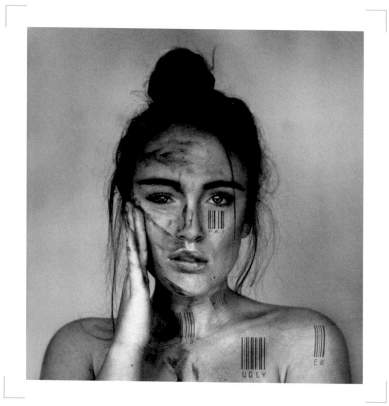

LABELS

SHOOT 45 MIN **CREATE** 30 MIN

SHOOT

What is important is that this image isn't perfect: the makeup isn't great, my hair is like a bird's nest. Because the makeup (black paint) is very dark, I needed good lighting, but my studio light was broken. I went and stood by the window. Do remember to turn the indoor lights off if you're going to do that.

The movement of the wiping needs to be visible as an ongoing process. I had to try that a couple of times before you really saw the movement. Often a pose doesn't feel natural but you find that it's exactly the position that shows the movement well. Here, that's in the positioning of the arm and hand. It's not a flat hand in front of my face; it's twisted so that you can see more face.

I produced the personalized barcodes on the website dafont.com and took screenshots of them.

CREATE

Because there is already so much to be seen in the photo, you really just need to add the barcodes.

+ Load the portrait of your face as the background.

+ Load a photo of a barcode as the foreground and position.

+ **Transform → Multiply**: You're left with just the black part of the barcode, like a tattoo.

+ Repeat for other barcodes. You can also place the barcodes partially "behind" the makeup so that the makeup and the barcode merge.

+ **Merge** and save. Finished!

IMAGINE

I was feeling happy and it was spring break, so I created this image with butterflies and flowers. I was interested in the mood, in the overall picture: Yes, it's spring!

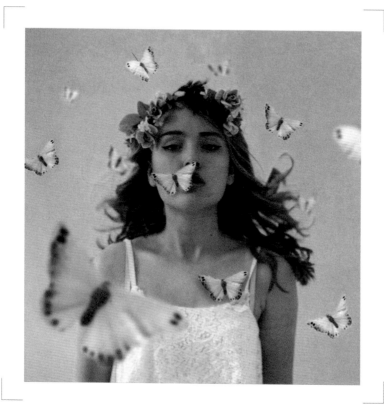

SPRINGBREAK

SHOOT 20 MIN **CREATE** 30 MIN

—

TAKE A CLOSE LOOK AT THE
TWO BUTTERFLIES ON MY
SKIN . . . THE SHADOW IS NOT
IN THE RIGHT PLACE FOR
EITHER OF THEM!

—

SHOOT

This image needs to contain movement, as if the wind is blowing
and you are being pulled through the image. It also needs to
contain depth and flamboyant hair. It's not easy to capture hair flip.
You can throw your hair in the air, but usually you make a very odd
face when you do it. So I used two photos: one of the hair flip and
one where I'm just looking up.

The nice thing about an image like this is that you can go crazy with the details. You can put flowers in your hair, choose whimsical clothes. Here, that adds something—everything has a bit of extra oomph. Because butterflies have a certain transparency, they are often merged with their surroundings in photos. If you get images from the internet, you will miss that transparency. With store-bought paper butterflies to photograph yourself, you can control the sharpness and depth, and take an unfocused image, like the butterfly in the foreground.

The portrait photo and the hair flip had the same background, and the lighting for these photos and those of the butterflies also had to be the same. I used natural light and stood several feet away from the wall in order to create depth and space.

CREATE

+ Load the portrait photo as your background.

+ Load the hair flip photo as the foreground.

+ **Mask:** Remove everything apart from the hair. You don't need to remove all of the background around the hair, since it's the same—you don't need to cut very accurately.

+ **Mask → Blur mask:** This makes the transitions on the edges of your hair more blurred and therefore smoother. You can also adjust the **Brightness** if necessary.

+ **Merge.**

+ Now you can add the butterflies: Load a photo of a butterfly as the foreground.

+ **Mask:** cut out butterfly.
 When positioning the butterflies, pay attention to the sharpness and the distance from your face. The focus is on the face. If the butterfly is just as sharp, you should place it close

to your face and cut it out tightly. Out-of-focus butterflies are in the near foreground or far background. Also look carefully at the proportions of the various butterflies: the size must match the position with respect to your face and with to the other butterflies (the closer they are to the lens/viewer, the bigger). You can cut out out-of-focus butterflies with **Mask** and a soft brush.

You can also place butterflies on your skin:

+ Load a sharp butterfly photo.

+ **Mask**: Cut out the butterfly.

+ **Merge**.
 Add a shadow where the butterfly blocks the light that falls onto your skin. If the sun is coming from the left, for example, there should be a shadow on the right.

+ Load a black photo as the foreground.

+ **Mask**: Use **Brush** to completely remove the black. That layer continues to exist but is temporarily not visible!

+ **Mask → Eraser**: The black will reappear where you wipe, or "erase."

+ **Blur mask**: Blur the edges of the shadow.

+ Set **Opacity** to 10% for a subtle (and not totally black) shadow.

+ **Merge** and save. Finished!

—

People often interpret photos personally, they project what's on their mind. I like to trigger recognition, not just show an image that's pretty to look at.

IMAGINE

Powder paint is used for color runs nowadays, but it also forms part of the Hindu Holi festival. I love colors, they make me happy, but I didn't want to just do something that would conflict with the original use of that powder paint. I stuck to a fairly innocent explosion of colors without too much around it.

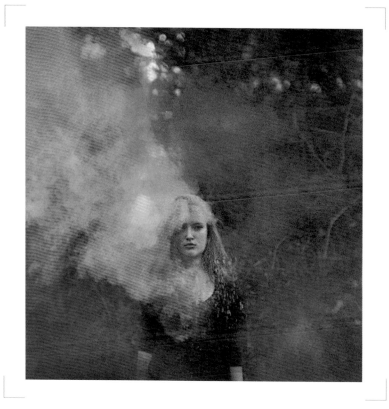

TRUE COLORS

SHOOT 90 MIN **CREATE** 45 MIN

SHOOT

This was really fun to do, but there are two disadvantages: You can't take this photo on your own, you need someone to throw the powder for you (my little brother!), and you get messy and cannot always get all the paint out of your clothes again. Oh yes, and these shoots always take a lot of time!

Powder Paint
First, check carefully whether you'll be able to get the paint out of your clothes and off your skin. Wear clothes that you don't mind getting dirty, and also look after your camera!

Close your eyes! You need to take a separate portrait photo with your eyes open. Do that midway through your shoot: you will already be covered with paint and still in the middle of the process, but you're not too messy yet.

>>

Throw the powder from the side in order to create the effect of an explosion and throw from different heights (so not just from over your head, but also at shoulder height so that it falls on your arms).

Remember, you don't need a really big cloud in order to fill an image. You can do that with expansions. So you don't need very much powder. Be sparing with the material, get the maximum out of it.

Take lots of photos: as soon as the powder is thrown take as many as possible so that you capture the whole process. You can mix the various phases together later.

Once you've done this once, you can use the photos of the clouds of color endlessly, with expansions, mirroring, etc.

The colors stand out better against a black or dark background. I went into the woods where you have an instant green backdrop, very chill. The starting point is a simple pose so that you can place various images over one another as easily as possible. But you can vary your shoulders and the expression on your face. The basic photo doesn't need to be really beautiful: it serves mainly as a background and it needs to be effective.

——

CREATE

+ Choose a portrait photo with the face that you want to use an another photo(s) of your subject that shows the paint explosion well. Load the face image as the background and the other photo(s) as the foreground.

+ **Mask**: Use a soft **Brush** or **Eraser** to remove parts that aren't needed, so that you keep details from both photos.

+ **Merge** into one flat image. Save.

+ Repeat if you want to use more details from other photos. Work from the inside outward: looingk at the color clouds closest to the body, then farther away.

+ If necessary, you can create **Expansions**: Choose a canvas and load your basic image.

+ Load photos for extra surroundings or color clouds. The background (out of focus, dark foliage) can simply be included and enlarged.

+ **Merge** and save. Finished!

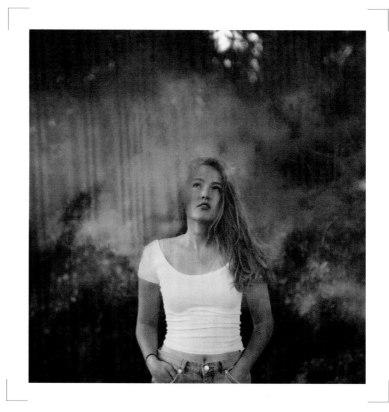

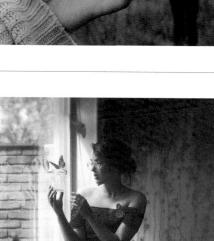

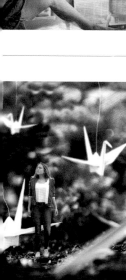
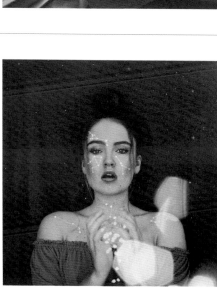
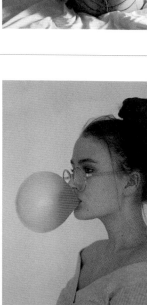

IMAGINE

I had never worked this idea out properly, but it had probably been in my mind for about four years. Sometimes people in films fall asleep, and then you don't know if what happens next is dreaming or real. I wanted to create something like that: I'm lying in my bed, but am I awake or am I only dreaming?

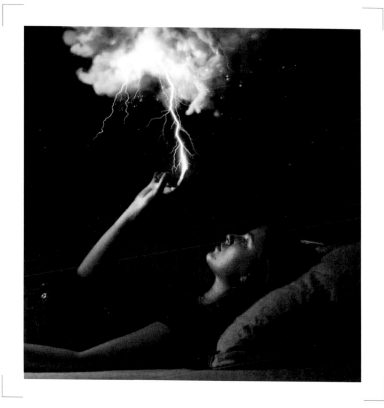

LIGHTNING

SHOOT 30 MIN **CREATE** 30 MIN

Strike a Pose
Make sure that you don't make any unnecessary shadows: the light on the face and arm must be the same, so the arm shouldn't cast any shadows on your face.

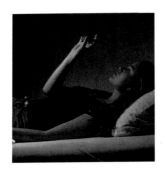
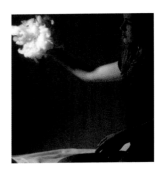
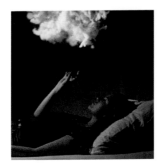
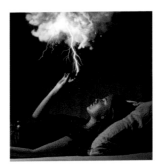

SHOOT

In this photograph, everything is as real as possible, so I had control of the light in the cloud and all I needed to edit was the lightning flash. Highlights that are illuminated by the lightning are visible, and everything around them must be fairly dark. By putting a bright studio light on myself from above, everything around it automatically became dark in the exposure. You could also achieve this effect with a flashlight if you render the light from the flashlight blue or white in the edit, instead of yellow. The rest of the photo is simple. Having a lot of details or clutter on the bed can make it look messy.

I made the cloud out of wool stuffing, with a flashlight inside so that there is real light coming out of the cloud itself. The background here must be dark. The lightning flash image came from the internet. It must be sharp and clear, without too many branches.

▬

CREATE

+ Load the photo of your subject in bed as the background.

+ Load photo of the cloud as the foreground.

+ **Mask**: Because the background of both photos is dark, it's okay to have blurred transitions. You don't need to cut tightly.

+ **Merge**.

+ Make the connection between the cloud and the person: the lightning flash.

+ Load the photo of the lightning as the foreground.

+ **Transform → Screen**: Only the lightning is left, shadows disappear. There may still be some color around the lightning, so set **Saturation** to 0, then they will disappear. Check whether you should adjust the brightness of the lightning flash with **Brightness** and **Exposure**.

+ **Transform**: Position the lightning, paying attention to the transition between the finger and the lightning. Place the flash so that it connects well to the fingertip. Possibly blur the edges with **Blur mask**.

+ **Merge** and save. Finished!

IMAGINE

The theme of this image is vulnerability, about appearing strong but also being fragile. I wanted to show the vulnerability of my own face, the layer below. My mirror had just broken, and I kept the pieces to use in this image.

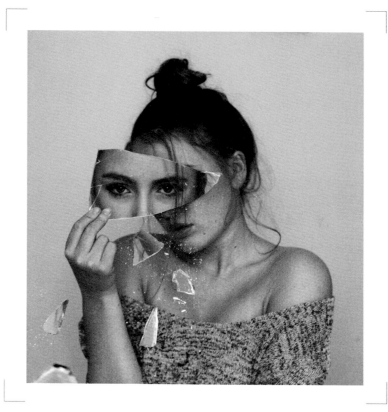

SELF DESTRUCTION

SHOOT 30 MIN **CREATE** 45 MIN

INSTEAD OF THE
LARGE PIECE OF
MIRROR I COULD
ALSO HAVE
USED A PIECE
OF CARDBOARD OR
SOMETHING HERE, BUT
THE SMALL BITS OF
MIRROR DO MAKE
THE IMAGE MORE
REALISTIC.

SHOOT,

In this photo it's important that the lighting is roughly the same everywhere, without too many shadows. I had no idea how the light and shade would affect the piece of mirror, so I kept the lighting as simple as possible and also chose a background without too much distraction. Instead of the large piece of mirror, I could also have used a piece of cardboard or something here, but the small bits of mirror do make the image more realistic. I also had to search for the right pose: how much of my face should I cover, how do I make sure that my hand is not too dominating in the picture? You look for the right balance between concealing and not concealing—when does the image retain its power?

For the final image, I needed a photograph of myself holding a piece of mirror, but also a photo for the reflection in the mirror. In that second photo, I looked straight into the camera precisely because I'm not doing that in the first photo. I also needed photos of the small shards of mirror, and I added more details from a photo of stars from the internet.

CREATE

+ Load the photo of your subject holding piece of mirror as the background.

+ Load the photo of the reflection as the foreground.

+ **Transform → Opacity** to 50%, so that you can see what part of the foreground you want to place on the piece of mirror. Finished? Set **Opacity** back to 100%.

+ **Mask:** Remove everything with a brush and then restore only the part over the piece of mirror. In this case it's easier to remove everything and "color in" the mirror again than to cut out everything around the mirror.

+ **Merge** and save.

+ Load your photo (s) of the loose shards.

+ **Mask:** Cut out the shards and position them. You can place shards anywhere, provided they're below the large piece of mirror (they're falling down).

+ **Merge** and save.

+ Repeat for more shards and **Merge** and save each time. Add details: below the small shards of mirror you can add tiny bits. I used an internet photo of stars for that.

+ Load a photo of stars as the foreground.

+ **Transform → Screen:** You're left with some white dots.

+ **Mask:** Remove everything with the brush and add it back in where you want to retain it. You would logically have more shards closer to the large piece of mirror than farther away.

+ **Merge** and save. Finished!

IMAGINE

I previously produced this concept more than three years ago,
and that photo has been viewed more than two million times and
has received more than 150,000 likes, which is an incredible
number! I'd made it very quickly and it was too orange, so I thought
I should make it again, but I always wait a while to do that. Then the
new photo gets fewer likes because people think they've already
seen it.

The photo of the eye is recycled—I had taken it for another
concept. I think it's interesting to create something new with
an old picture.

Everyone has something like planets in their eyes. Eyes are usually
not just one color. Sometimes you can see the Sahara desert in
brown eyes, sometimes blue eyes are reminiscent of a jellyfish—
I find that fascinating.

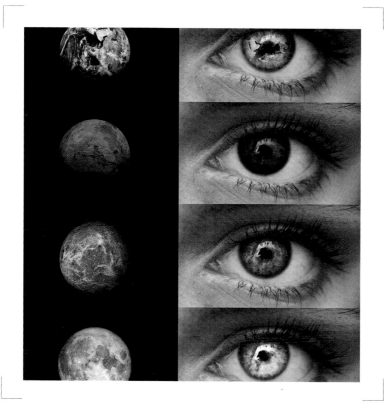

PLANETS

SHOOT 5 MIN **CREATE** 30 MIN

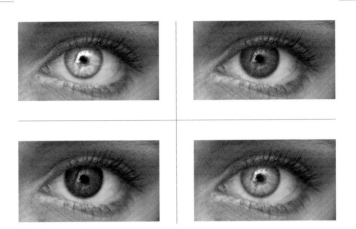

—

WHEN PHOTOGRAPHING YOUR EYE,
MAKE SURE THAT THE PUPIL IS CLEARLY VISIBLE.
AN EYE WITHOUT A PUPIL CAN EASILY LOOK
STRANGE OR CREEPY. USE AN INDIRECT BUT
REASONABLY STRONG LIGHT SOURCE.
PAY ATTENTION TO THE FOCUS: IT SHOULD
BE PRECISELY ON THE PUPIL.

—

SHOOT

The iris needs to be clearly visible in a photo of an eye. If too much shadow falls on the eye and then you edit the color, a lot of detail is lost. And preferably, there should be no reflection visible—it makes editing tricky. Here, the camera coincides with the pupil, so I did not have to get rid of it. You also need photos from the internet of the moon or planets in four different colors. The colors of the eyes will be matched to those.

CREATE

+ Trim the photo of the eye to the size that you want to use.

+ Load the photo of the eye as your foreground.

+ Increase the **Saturation**. The color becomes more intense, but the whole image—the entire eye—does, and you only want the color of the iris to be so intense:

+ **Mask**: Remove everything around the iris from the photo in the foreground.

+ **Merge** and save.

+ Load the photo of the eye with intense color as foreground: it's the same image as the background.

+ Alter the color of the foreground image using **Filter → Hue**. Compare the color with the color of the planets in the internet photos. You want those colors to be the same. Save the four different settings. If you've chosen a picture of the Moon and you want a matching silver-gray eye, set **Saturation** to 0. For every eye, you now need to remove everything from the foreground, apart from the color in the iris.

+ **Mask**: Remove everything around the eye. Use **View mask** for this: the foreground and background are the same, and this allows you to see clearly what you're removing from the foreground.

+ You can now place the planets and the moon over the eyes.

+ Load a photo of an eye with a modified color as your background.

+ Load photo of a planet or the moon as the foreground: **Transform → Overlay**, **Screen**, **Multiply**, etc. Select one of the various options and see what works best for your eye and the

color. You will see a different structure in the eye. You want to strike a balance between what you still see of your eye and what you see of the planet or Moon. You also need to make sure that there is balance between the various eyes.

+ **Mask**: Remove everything using **Brush** and only restore over the iris.

+ **Merge** and save. You do this four times in total, once for each eye color. So you end up with four final photos of the eyes in the same color as the planets with the texture of the planets in the iris.

+ Make a collage of the eight final photos of eyes and planets. Check the proportions: the planets should all be the same size, and so should the eyes.

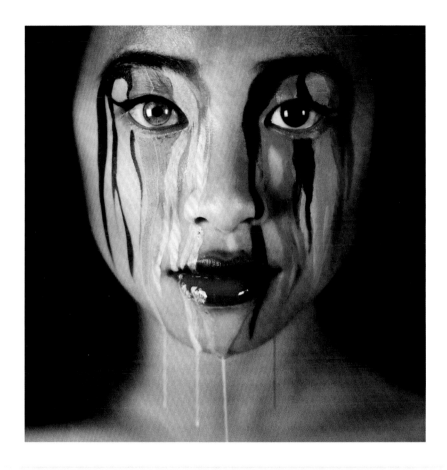

escapingyouth

NATALIA SETH UNITED STATES **201,000 FOLLOWERS**

Natalia and I started at about the same time—we're the same age. We also have similar style, but she has a lot of sense for clothing. I think it's clever how she incorporates that in her photos. Although she probably also just photographs at home like me, she creates strong studio portraits. She makes good use of lighting and her use of color is always balanced. It's nice that she is sometimes more abstract than I would be. She may make her photos less realistic, but the concepts remain strong.

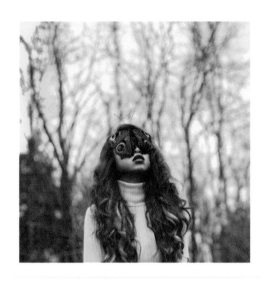
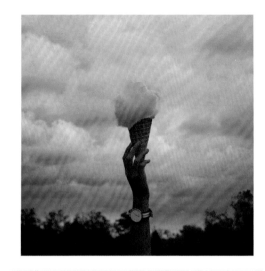
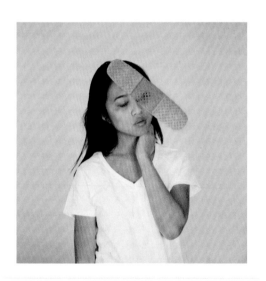
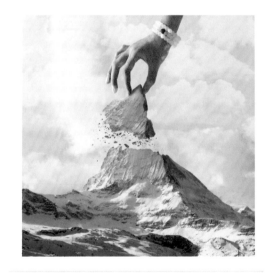

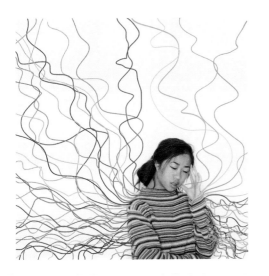

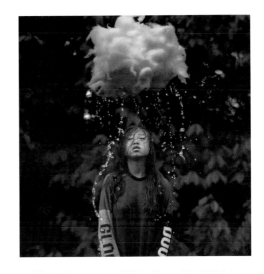

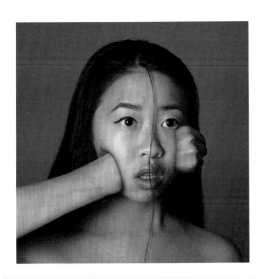

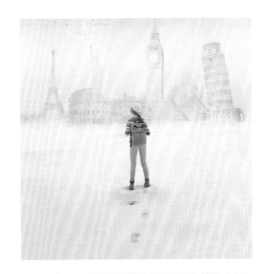

IMAGINE

I like creepy things, but I know my audience: my photos cannot be too scary. In this case, I did want to make the viewer uncomfortable, with hands everywhere. The image has a particular mood, and that is determined by the shoot.

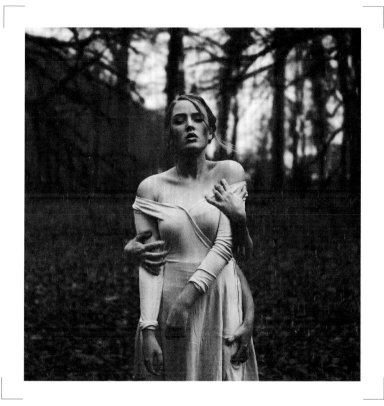

LOSE YOURSELF

SHOOT 45 MIN **CREATE** 90 MIN

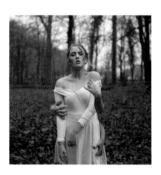

SHOOT

I had to go outdoors for this photo! The forest was a perfect setting, combined with the feminine dress—it all contributes to the mood. If I'd been a boy, a bare torso would probably have been most suitable. But only do that yourself if you feel comfortable with it.

There had to be more than two extra hands around me; otherwise, the viewer could still see it as a second person. The third hand gives it something supernatural. It was also tricky to hold myself as if I were being held by other hands. I twisted myself into all sorts of shapes. The basic position must radiate powerlessness, so there had to be a difference in the passive hands in the basic photo and the grabbing hands in the other photos.

In a photo like this, always be aware of your sleeves: roll them up so that the skin is visible and you won't have any problems with odd bits of sleeve. The hands appear to come out of nowhere or out of your body, and they must not overlap when you place the various photos on the basic photo. So take lots of photos in many different poses. A hand which is an inch too far to the left or right can be the difference between a successful, achievable edit and one that doesn't work.

CREATE

This edit takes quite a long time!

+ Load the photo of your subject in a passive position as the background.

+ Load the photo of hands/arms as your foreground.

+ **Transform** → set **Opacity** to 50% so that you can see clearly where you want to place the hands or arms. After positioning them, set **Opacity** back to 100%.

+ **Mask**: remove everything with **Brush** and add hand/arm where you want to place it.
Ensure smooth transitions: You can include the shadow of the hand and the edge beside it, and fade that edge with **Blur mask**. If you include the shadows, you can remove the rest smoothly and you don't need to cut very neatly. Because the background color of the clothing is the same everywhere, the transitions will also stand out less. Make sure the movement of the hand or arm is coming from behind. Sometimes you need to remove the whole arm, and sometimes you can keep part of it. That makes the image more realistic.

+ **Merge** and save.

+ Repeat this edit if you want to add more hands.

IMAGINE

Sometimes you have no inspiration, your archive is empty, and you cannot come up with a concept. In this case, I happened to be listening to music: those flamboyant, cheerful Disney tunes! Then I watched a film as well, and I wanted to create magical, something with childhood sentiment. I believed for a long time that all my stuffed animals could talk to me, I believed in all sorts of things, and with this photo I show the link between astuffed animal and child—a wonderful feeling that I used to have.

A lot of people enjoyed this photo: it got a lot of likes.

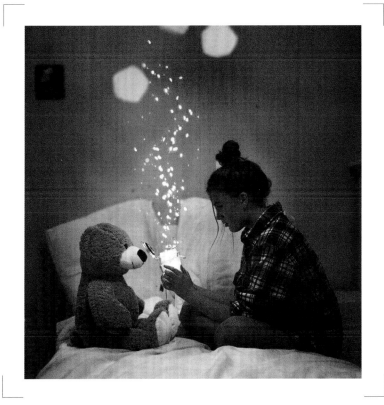

IMAGINE

SHOOT 30 MIN **CREATE** 20 MIN

 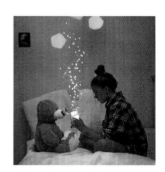

SHOOT

By building a kind of triangle in the composition, I wanted to create intimacy. The bear and I are bending towards one another, as if we have a secret. Otherwise, the setting is simple: my bed. That was quite a challenge, since my room is usually a mess. It looks neat here, but that certainly doesn't reflect in real life.

I quickly discovered that the bear could not sit upright on its own, so a photograph of me and the bear sitting on the bed wouldn't work. I photographed the bear on the bed separately, and then myself with the jar in my hands. That jar really did give light: there's a string of small battery-powered LED lights in it. That looks magical in itself—you don't need to do anything to it in the edit! And that light is so weak that you don't need to allow for reflection or light on the surroundings.

Make Your Photo More Real

Can you make your photo more real by getting hold of the right props? Then do it, even if it means that you can't take the photograph at that moment. It's better to wait a day and make sure that your materials are ready. Waiting is worth it: better in real life than in the edit.

Pay attention to the camera's position: it needs to be precisely the same for the photo of the bear and your subject, so that you can stick the photos onto one another easily. It's best to use a tripod. The photo was taken from the foot of my bed, fairly close-up, so I already knew that I would have to make an expansion. More space around the bear and me emphasizes the intimacy. I also wanted the color of the wall in the background to be clearly visible—it contributes to the mood, as does the warmer light of the ordinary lamp that I used. That's unusual, but the light from my studio fixture would probably have been too harsh here.

For the firefly sparks I needed a photo from the internet of a cloud of sparks against a dark background.

CREATE

First you're going to merge the photo of your subject and the photo of the bear.

+ Load the photo of your subject as background.

+ Load photo of the bear as the foreground.

+ Mask: Keep the part of the photo with the bear that joins smoothly to the background. Because a lot is the same in both photos, you can easily make the transitions smooth. When masking, make sure that you keep all important details from both photos.

+ Merge and save.

+ Check whether you need to adjust the exposure with Brightness, Exposure, and Contrast.

+ Load a blank canvas as the background, then **Import background** → **Pick color** → choose dimensions.

+ Load the photo of your subject with the bear as the foreground and position it on the canvas.

+ Make an **Expansion**: Load the photo(s).

+ **Mask**: Use soft **Brush** to remove what you don't need; keep extra wall, air, floor, etc., but don't make it too tricky. Only add where you need it.

+ **Merge** and save.

+ Add sparks: Load the photo of sparks.

+ **Transform** → **Screen**: Only the highlights remain, floating lights.

+ **Transform**: Position.

+ **Merge** and save.

+ Repeat if you want to add more sparks.

—

I try to hang on to
the magic that
most people lose.

IMAGINE

Who wouldn't want to float away on a bunch of balloons?
I always wanted to develop that cliché image sometime.

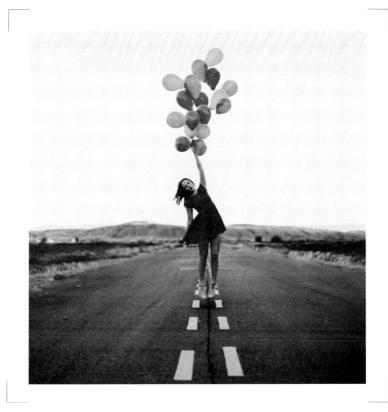

FAVORITE DISNEY MOVIE

SHOOT 45 MIN **CREATE** 45 MIN

 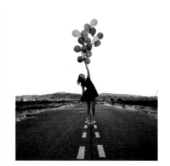 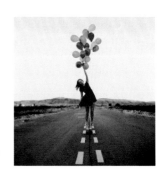

SHOOT

There are no nice roads or open spaces near me. I was looking for an empty landscape like in the middle of the United States, but you just don't have those in the Netherlands. On an industrial park, I did find a piece of road with that double centerline that I wanted to use. So the photo had to be taken in such a way that I could remove the background and replace it with a landscape from the internet. If I'd have a nicer setting nearby, this photo would have been a lot easier to create!

The background behind my hair had to be white, so that I wouldn't have to cut it out. That meant that I waited until the sun went down. The floaty dress also contributes to the "flying movement" and the color makes a good contrast with the black pavement. The bunch of balloons is real, and I photographed them in the same strange light just when the sun had set.

Incidentally, you need two basic photos: one with one leg in the air, and one with your other leg in the air.

Finding a good image for the background on the internet was very tricky in this case. It had to be a good image, the lighting and perspective had to be right, the sky had to be white, and the image had to be good quality and free of copyright (many landscape photos aren't!).

CREATE

+ Load the photo of the basic position, with one leg in the air, as your background.

+ Load the photo with the other leg in the air as your foreground.

+ **Transform → Opacity**: set to 50%. Position the foot (and part of the leg). Finished? Restore **Opacity** to 100%.

+ **Mask**: Remove everything apart from the foot and part of the leg. Pay close attention to the transition.

+ **Merge** and save.

+ Load the photo of the background as your background. Check that the photo works, look at lighting and perspective.

+ Load the photo of your subject as the foreground.

+ **Mask**: Remove what you don't need. Check details like the space under your armpit and between your legs so that you don't still see part of the foreground photo there. If necessary, adjust **Opacity** so that you can see clearly what you're doing. Make sure the transition from the foreground to the background is smooth, and keep it blurred. The image must appear believable, but the transition does not have to be 100% right. Adjust **Brightness** and **Exposure** if necessary.

+ **Merge** and save.

+ You can now add the balloons.

+ Load your photo of balloons as the foreground.

+ **Mask**: Make sure that the transition is smooth. Because the balloons were photographed against a white background and the sky is also white, you don't need to cut out the balloons.

+ **Merge** and save. Finished!

IMAGINE

My idea here was an umbrella that the rain would fall off in various layers of color. For this photo, I experimented with new techniques. I wanted to see how I could work with colored water and explore how it would fall.

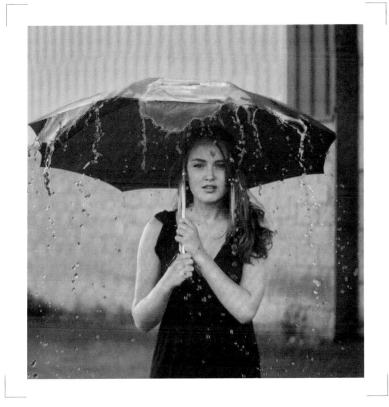

DON'T BE NORMAL

SHOOT 60 MIN **CREATE** 60 MIN

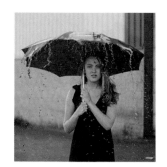

SHOOT

You might think that I could easily have changed the color of ordinary in the edit, but I wanted to add an extra dimension to the photo and work with real colored water. So this is primarily a real photo. I filled bottles of water and added red and green colorants to them. I knew that I could create extra colors in the edit.

The location was important: In order to clearly show the dark umbrella and the colors of the water, I needed a light background, but not so light that the water would be lost against it. Nor could the background be too fussy, and the location would preferably not be too far from my house: I needed to carry six bottles of water on my bike. In the end, I found myself somewhere on an industrial park. When I posted the photo a day later, someone commented that they had seen me from their office window.

Limited

The colored water was my restriction with this shoot, a limited resource. What should I do when it ran out? Could I refill my bottles, did I have time for that? When choosing a location, think in advance what you will need. And when you've nearly used up all your material, look carefully at the photos that you've already taken to see what works and what doesn't. Is it worth carrying on? Do you need to modify something? If necessary, you can do a quick pre-edit on the spot: Place a couple of images over one another in order to assess whether you're on the right path and can work with them in the edit. Use the self-timer and get the camera to take lots of photos in quick succession, not just one. You will then see the movement of the falling water, and there is a greater chance that there will be something usable among the shots.

The colors of the water meant that dark clothing was most useful here. In addition to a photo of myself with the umbrella, I needed several photos of that umbrella at roughly the same height (with the same background and the same lighting) with the water going over it. As extra material I took photos of the water splashing up, without the umbrella, so that I could use small details from that. Make sure that an object—the umbrella in this case—is in the same position or angle in different photos. The perspective must be the same, otherwise you cannot use all the photos. To check that you can, swipe between the various photos or carry out a quick pre-edit if you're not sure.

CREATE

+ Load photo of your subject with an umbrella as the background.

+ Load one of the photos of the umbrella with falling water as the foreground.

+ Transform → set **Opacity** to 50%. See where the water falls on the umbrella and find a smooth transition between the umbrella in the foreground and the umbrella in the background. Position and then restore **Opacity** to 100%.

+ Mask: Remove everything with **Brush** and then restore parts of the foreground with a softer **Brush**. The transitions are then easier to check. Do not leave the foreground transparent.

When working with a soft **Brush**, you need to brush several times in order to make sure that the added layer is fully visible.

+ **Merge** and save.

+ Repeat: Load different photos of the water as foreground and add the colored water in different places. Depending on the foreground and background, you should use a harder or softer **Brush**. For the red water on the left that falls partly on the umbrella and partly off it, and therefore has both a dark and light background, you will need a harder **Brush** and you need to cut more tightly. The green rain at the far right is placed against a dark background and also has a dark background, so there you can work with a soft **Brush**.

+ **Merge** and save.

+ Now you can add some extra color to the water.

+ Load the edited photograph that you saved as both your foreground and your background. Keep the same settings for both. Change the **Hue** of the foreground: the colored water will change to different colors. Choose color.

+ **Mask**: Remove everything apart from the part that you want to give the new color.

+ **Merge** and save.

+ Repeat: Adjust **Hue** and choose a color for another part of the water. Use **Mask** to remove everything from the foreground that you don't want to keep. Only the part of the water with the new color is retained. **Merge** and save. Repeat until you have the desired result.

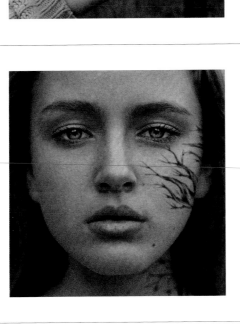

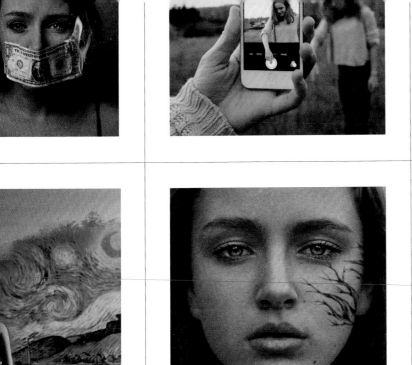
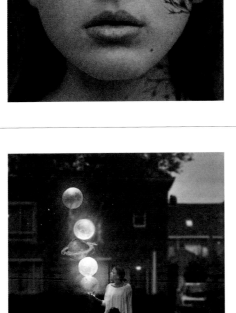
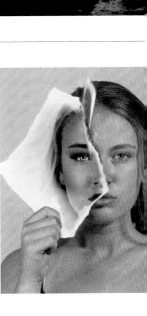

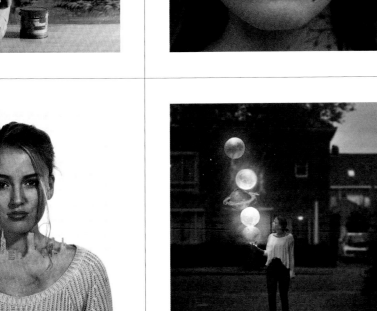

IMAGINE

Here I am studying for my physics test. I felt that I was drowning in the chaos and was reminded of the film *Life of Pi*, of being lost at sea. I don't live by the sea, but I could bring the sea into my room.

 This is one of the most edited images that I've created. If you want to do this right, it'll take you a lot of time, particularly for the Create phase.

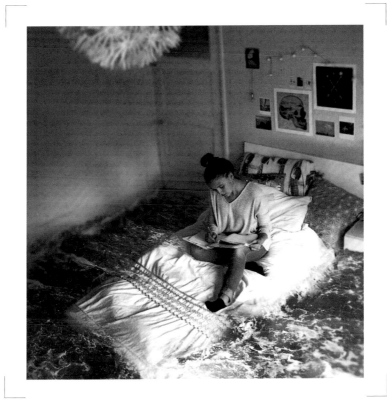

STUDYING FOR MY EXAMS

SHOOT 30 MIN **CREATE** 120 MIN

Really Out of Focus

Out-of-focus elements only look realistic if they would have been out of focus in a regular image as well. In this case, in the basic image, the floor by the wall and door at the back are out of focus, and so you can make the water that you place there out of focus too. Don't blur the background just because it looks good—it won't make your image more realistic.

DIFFICULT SET-UP? IF SOMEONE CAN TAKE THE PHOTO FOR YOU, IT REALLY IS BETTER! OTHERWISE PLACE YOUR CAMERA IN A STABLE, HIGH SPOT.

SHOOT

In order to be able to show water in my room, I really wanted to capture my whole room in the photo, including myself. That's hard to do, so the obvious solution was to make an expansion and photograph the room in parts. I needed a high position, which I could only do by being reckless with my camera: it was lying sideways on a pile of clothes on top of the wardrobe. I could just reach it in order to press the self-timer, and then I had 10 seconds to go and sit on the bed. I had to take the other photos of the room from the same angle as much as possible, so I stood on my desk. The various photographs did not need to contain exactly the same thing: I was going to replace the floor in the foreground with water, so it didn't have to be included in every photo.

In addition to my photos, I used a photo from the internet of water with different colors and waves or flow: this brings more texture to your image than flat water, and allows you to play with the colors. Ideally, the photo of the water should have been taken from above. If you can't find a photo like that, you can manipulate the perspective by adjusting the proportions of the photo slightly in **Transform**.

CREATE

+ Start by making an **Expansion**:

Making Mistakes

The first thing that I see in this photograph is a mistake (look for a rectangle near my shoulder). Everyone makes mistakes, and most are not noticeable. Nobody has ever said anything about it, even though there are more than 1000 comments on this image. Only you know the process, and so making mistakes is not a problem.

+ Choose a background color and a size for your canvas.

+ You will combine the various photos on this to form one image. Transitions must be subtle with soft edges.

+ Load a photo of water as the foreground.

+ Mask: Use **Brush** to remove water and then restore with **Brush** or **Eraser** where you want to see the water; in this case, where the floor is visible. Keep transitions vague; waves can also partly go over the bed.

+ To create more depth in the image, you can differentiate between the water that is close to the light source (to the right of the bed) and father from the light source (to the left of the bed), creating the illusion of shadow. Load a photo of water and use **Mask** to add water on the side of the light source. Keep this water light. **Merge** and save.

+ Load another photo of water and use **Mask** to add water on the dark side of the room. Adjust **Brightness** and **Exposure** so that the water is darker.

+ **Merge** and save.

+ Because the overall image consists of various photos, everything is equally sharp all over. That's not realistic. You can make the image more realistic by adding blur to the image where something is farther away or closer than the part on which the focus lies.

+ Load the final image as both the foreground and the background.

+ Mask: Use **Brush** to remove foreground, and restore parts of the photo in the foreground with **Blur mask**. In this case, blurring has been added by the wall in the background, in the right-hand corner at the top, and by the door.

+ **Merge** and save. Finished!

An Hachette UK Company
www.hachette.co.uk

First published in Great Britain in 2019 by Ilex,
an imprint of Octopus Publishing Group Ltd
Carmelite House
50 Victoria Embankment
London EC4Y 0DZ
www.octopusbooks.co.uk

Photography by Annegien Schilling, with photos by Adam Bird (page 65),
Isabella Madrid (page 98), and Natalia Seth (page 133)
Text by Eva Reinders

Distributed in the US by Hachette Book Group
1290 Avenue of the Americas, 4th and 5th Floors, New York, NY 10104

Distributed in Canada by Canadian Manda Group
664 Annette St., Toronto, Ontario, Canada M6S 2C8

Publisher: Alison Starling
Commissioner: Frank Gallaugher
Managing Editor: Rachel Silverlight
Translation: First Editions
Art Director: Ben Gardiner
Production Controller: Grace O'Byrne

ISBN 978-1-78157-732-5

A CIP catalogue record for this book is available from the British Library.

Printed and bound in China

10 9 8 7 6 5 4 3 2 1